A Memoir of

Vincent van Gogh

Harvest: the plain of La Crau, 1888

Previous page:
Head of a Girl,
17 June 1888

Following page:
Cypresses, 1889

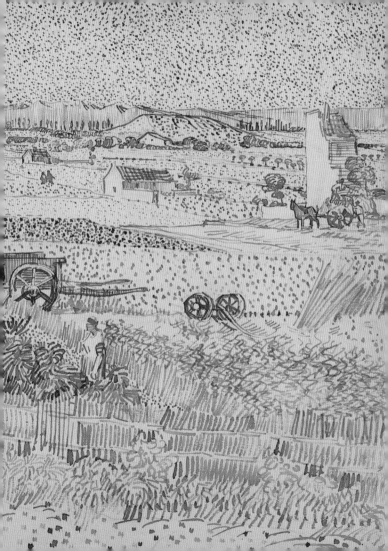

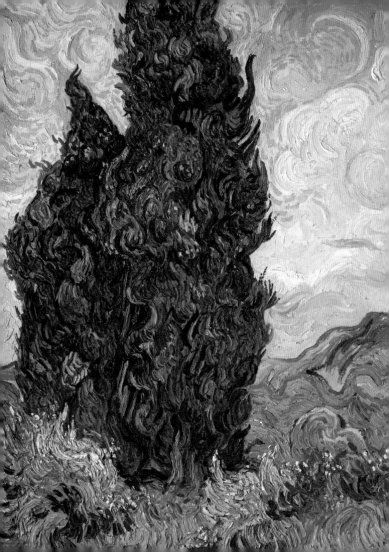

A Memoir of
Vincent van Gogh

Jo van Gogh-Bonger

Introduction by Martin Gayford

The J. Paul Getty Museum, Los Angeles

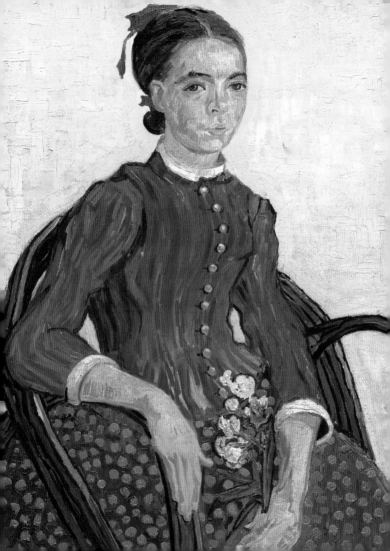

CONTENTS

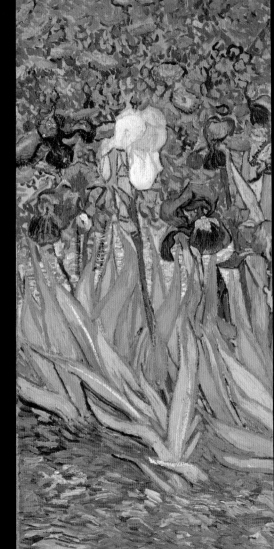

Irises, 1889

One of the paintings chosen by Van Gogh's friends to hang in the room where his body lay before his funeral

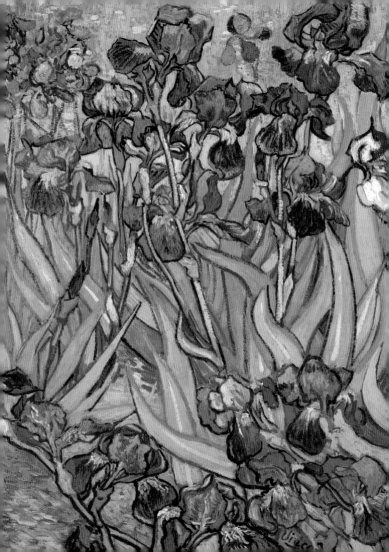

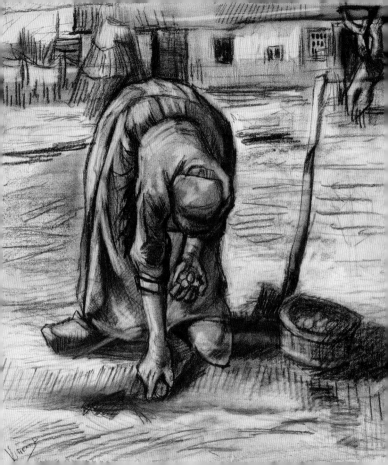

INTRODUCTION

MARTIN GAYFORD

In July 1887, a young Dutchwoman confided her innermost thoughts to her diary. She had just turned down a suitor for her hand who had – quite out of the blue – declared his love. Even so, the prospect of a future life had opened up. 'He conjured up visions of the ideal I have always dreamed of,' she wrote, 'a rich life full of variation, full of intellectual stimulation, a circle of friends around us who were working for a good cause.' Her 'indefinable searching and longing' would be transformed into 'a clearly defined duty': to make him happy.

In the short term her hopes were cruelly disappointed. Eighteen months later she met her suitor again, and this time when he put the question she said yes. But, less than two years later her newly-wed spouse was dead of tertiary syphilis, leaving her with little in the way of inheritance except a baby, a huge quantity of paintings by his brother – an unsuccessful artist who had died six months previously – and an enormous archive of letters mainly from this same

Opposite: Peasant woman planting potatoes, August 1885

eccentric sibling. Yet in a strange way, her marriage did result in a life of duty and dedication to a cause.

The young woman who wrote so romantically in her diary was Joanna – or Jo – Bonger, then a 24-year-old teacher of English and daughter of an Amsterdam insurance broker. Of course, the man who wooed her so determinedly was Theo van Gogh, and his ne'er-do-well brother was Vincent. Posterity owes Joanna an enormous debt. It is not hard to imagine a widow, bereaved in such circumstances, simply abandoning her strange bequest: consigning both Vincent's works and his words to an attic, or the late 19th century equivalent of a skip.

Instead, she devoted the remaining three and a half decades of her life to fostering the reputation of Vincent van Gogh, 'deciphering and ordering' his correspondence, translating it into English and – not least – writing this short biography, *A Memoir of Vincent van Gogh*. In many ways, Jo van Gogh-Bonger set the tone and image of this great artist for years to come. Even today, in some respects, we think of Vincent as she presented him. As the partner of Vincent's greatest friend and confidant – his brother Theo – she had insights and recollections that no one else then possessed.

By 1913, when she wrote this text, Jo was also a

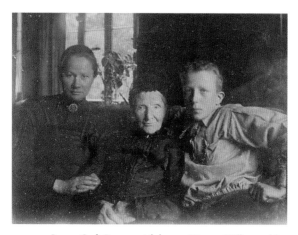

Jo van Gogh-Bonger, with her son Vincent-Willem and her mother-in-law Anna Cornelia van Gogh-Carbentus, c. 1903

leading member of the Van Gogh family. She was the mother of the sole heir, named Vincent after his uncle. For many years she was close to her mother-in-law, Anna Cornelia van Gogh-Carbentus, who outlived her sons by many years and had died in 1907, aged 88. It is to her that the memoir – published as a preface to the first edition of the letters – was informally dedicated. 'In this book which is a monument to her sons, a word of grateful remembrance is due to their mother'.

Memory of the Garden at Etten, November 1888. The figures in the foreground may represent Van Gogh's mother and his sister Willemien (or possibly Kee Vos Stricker)

No biography is truly objective, that is a human impossibility, and these 'memories' less than most. Jo wrote from the point of view of the Van Gogh family. This was both her value as a witness – no group of people knew Vincent better – and an explanation of its lacunæ, the aspects it skirts around or omits altogether. She was Vincent's sister-in-law, and the custodian of his reputation; she was also – perhaps to a greater extent than she realised or at least acknowledged to herself – a participant in the drama of his life.

Jo had met Vincent himself face to face only on three rather brief occasions in the early summer of 1890, beginning with her first sight of him on May 16. 'I had thought I would see an invalid, but in front of me stood a sturdy, broad-shouldered man with a healthy complexion, a happy expression and a very determined look.' Her first thought, she remembered, was 'He is completely healthy, he looks a lot stronger than Theo.'

On that day Vincent had come straight from the Gare de Lyon, having travelled from Provence on the overnight train. Her impression was accurate, but misleading. The painter was probably in a better physical state than he had been for a long time because in the hospital at St Rémy, where he had spent the previous year, he had been fed regular meals and led an existence

that, though solitary and dull, was much better regulated than when he was left to his own devices.

Jo's brother Andries, who had known Vincent for much longer because he was a close friend of Theo's, thought much the same. 'He looks better than he ever has,' he wrote at the time, 'and has become rather fat.'

Therefore Vincent doubtless did look much better than Theo, who was – though nobody then knew it – only a few months way from collapse into paralysis and insanity. But Vincent's own appearance of mental equilibrium was deceptive. Andries Bonger noted, with a touch of surprise, that 'He talked quite normally and was cheerful.' But Vincent himself had recovered only very recently from a crisis that had left him for weeks in a state of depression so deep that he refused or was unable to speak.

In the following two months, Jo met her brother-in-law twice more. On June 8 she, the baby and Theo went to Auvers-sur-Oise, where Vincent was staying and had an idyllic day in the country. On July 6, Vincent came to Paris to pay them a visit, and the result was – in the febrile mind of the painter – an ugly row. What probably occurred was more a discussion about finances, in which opinions were divided.

Theo was considering leaving the art dealer's at which he was employed, and going out on his own. Jo

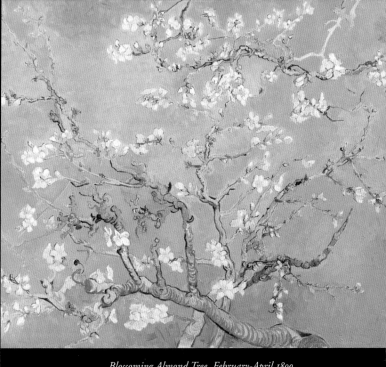

Blossoming Almond Tree, February-April 1890
Given by Vincent to Theo and Jo to celebrate the birth
of their son Vincent-Willem

seems to have clashed with Vincent. Exactly what was said is unknown, but she may have pointed out that while her husband was supporting his artist brother as well as her and their child such a course was risky. Vincent was stricken – puzzlingly so, Theo felt, since this was in reality doubtless a mild dispute. He wrote from Auvers how he felt that things looked black both for Theo and himself. 'I usually try to be quite good-humoured, but my life, too, is attacked at the very root, my step also is faltering.' Before the end of the month, Vincent was dead, having shot himself (or so at least, everyone believed at the time, his latest biographers have raised the possibility that his death was in fact due to an accident).

Vincent's illness was probably inexorable, whatever it was. He was suffering crises every few months, of increasing severity. If he had not died when he did his fate might well have been that of his youngest sister Wil, who spent the later decades of her life in a mental institution in a catatonic state. The youngest brother, Cor, also seems to have killed himself, in poorly documented circumstances.

There was good reason for Jo to soft-pedal the matter of Vincent's mental problems. After all, she was devoted to establishing him as a great master, and there was already ample discussion – partly emanating

from Gauguin – of Vincent, the mad prophetic sage. In addition she was the mother of a Van Gogh, and must have had occasional doubts as to whether the trouble from which at least two of the siblings suffered was hereditary. The facts that in the early 1880s Vincent's parents had tried to have him committed to an asylum, and – on a separate occasion – had consulted a specialist in psychological problems, were suppressed so thoroughly that they only emerged in recent decades.

Whether Jo's presence in Theo's life was a trigger for Vincent's crises is an interesting question. She herself noted that it was immediately after the announcement of her engagement to Theo that Vincent suffered his attack and ear-cutting episode just before Christmas 1888. Martin Bailey has established that Vincent had received a letter from Theo – doubtless with the good news – prior to this calamity.

Vincent included the envelope in a still life he painted shortly after his recovery – though whether as a sign of joy or anxiety is not clear. Perhaps he felt both happiness for his brother and worry about his own financial security, for which he was entirely dependent on his brother.

In the immediate aftermath of Vincent's death, Jo was guilt-stricken. On 31 July she wrote to Theo: 'If

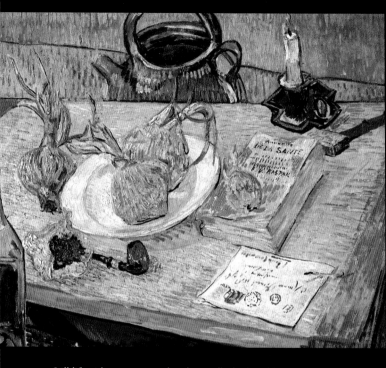

Still life with onions, pipe, absinthe, candle, book and letter, 1889

only I'd been a bit kinder to him when he was with us!' and on 1 August: 'How sorry I was for being impatient with him the last time.' Theo's own reaction was a determination to show the world that Vincent, as he wrote to their sister Lies, had been a 'very great artist'. But he himself had little more time. He collapsed shortly after Jo's birthday, on October 4, never to recover.

The duty he had felt became hers, indeed it was a double one; to foster Vincent's memory, and also Theo's (it was her decision that they should lie side by side in the cemetery at Auvers). She sold the apartment in Paris, moved back to the Netherlands, bought a villa at Bussum near Amsterdam and set up a boarding house. This provided income for her and her son in the short term, but her aim in life became promotion of Vincent's work through sales and exhibitions.

According to an inventory made by her brother Andries, she inherited 364 paintings (plus drawings and letters). By the early 20th century, she had sold around 100 works. In 1905 she organised a colossal retrospective at the Stedelijk Museum in Amsterdam – thus cementing Vincent's reputation. After the First World War she sold little although shortly before her death in 1925 she agreed to sell the greatest of all the Sunflowers pictures to the British national collection,

in tribute to Vincent's years in London – described in the memoir – and also perhaps because of her own anglophilia.

In writing about her now-celebrated brother-in-law, Jo had a delicate balance to strike. On the one hand, she must have wanted to emphasise how, in the words she quotes from Dr. Gachet, he was 'a colossus' as an artist and 'besides a philosopher'. And not, as the counter-legend had it, a crazed, irascible and drunken outsider (the drinking was a detail she chose not to mention).

On the other hand, even more than Vincent she wanted to preserve the memory and achievement of Theo. Hence it was necessary to touch on Theo's forbearance and Vincent's impossibility, 'of all that Theo did for his brother, there was perhaps nothing that entailed a greater sacrifice than his having endured living with him for two years' ('endured' is a most telling word). Indeed the testimony she hands on about the difficulty of flat-sharing with Vincent – how the compulsively talkative painter would pull up a chair beside Theo's bed and harangue him as the latter tried to sleep – are among the unique and valuable ingredients of her memoir.

There was a point to be negotiated here. It is clear that – devoted as he was to his brother and however

great the sacrifices he made for him, Theo – like almost everybody else – found Vincent easier to deal with, and to love, at a distance. During the period of over two years that Vincent lived in the South of France, the latter part of it in isolation as a patient in hospital, Theo visited him just once – in the aftermath of the debacle of Christmas 1888.

It is evident from the letter Jo quotes that Theo would have preferred him not to return to Paris in 1890, perhaps wisely. But such attitudes became problematic once Vincent had been metamorphosed in the eyes of the Van Goghs and all those of the world from crack-brained outsider to transcendent genius. However, in this regard – though she understandably avoided certain facts, such as her husband's syphilis and Vincent's drinking – Jo got the balance about right. For her, for Theo and indeed for us, there are two sides of poor Vincent that have somehow to be reconciled.

On the one hand, there was the artistic colossus, eloquent, wise and moving in his letters. On the other was the actual person from whom even his devoted brother liked to be separated by several hundred miles. This is a paradox for every biographer, and one Jo Bonger understood better than anyone, at first hand.

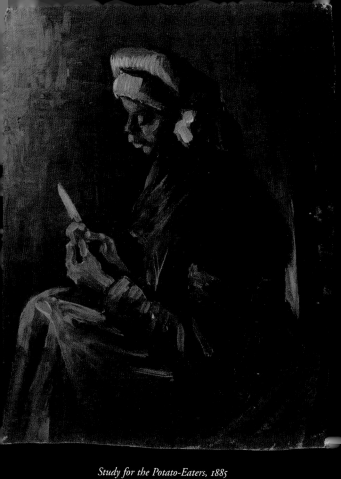

Study for the Potato-Eaters, 1885
with Self-portrait in a straw hat, 1887, painted on reverse

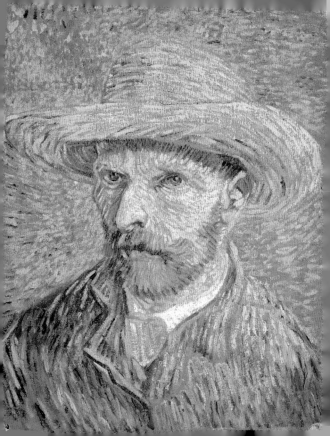

Jo van Gogh-Bonger

A Memoir of Vincent van Gogh

December 1913

The family name, Van Gogh, is probably derived from the small town Gogh on the German frontier, but in the sixteenth century the Van Goghs were already established in Holland. According to the *Annales Généalogiques* by Arnold Buchelius, a Jacob van Gogh lived at that time in Utrecht, 'in the Owl behind the Town Hall.' Jan, Jacob's son, who lived 'in the Bible under the flax market,' sold wine and books and was Captain of the Civil Guard. Their coat of arms was a bar with three roses, and it is still the Van Gogh family coat.

In the seventeenth century we find many Van Goghs occupying high offices of state in Holland, Johannes van Gogh, magistrate of Zutphen, was appointed High Treasurer of the Union in 1628; Michel van Gogh – originally Consul General in Brazil and later treasurer of Zeeland – was a member of the Embassy that welcomed King Charles II of England on his ascent to the throne in 1660. In about the same period Cornelius van Gogh was a Remonstrant clergyman at Boskoop; his son Matthias started as a physician in Gouda, and later became a clergyman in Moordrecht.

In the beginning of the eighteenth century the

Opposite: Vincent van Gogh, the painter's grandfather, 1881

social standing of the family was somewhat lower. David van Gogh, who settled at The Hague, was a gold-wire drawer. His eldest son, Jan, followed the same trade, and married Maria Stalvius; both belonged to the Walloon Protestant Church. David's second son, Vincent (1729-1802), was a sculptor by profession, and was said to have been in Paris in his youth; in 1749 he was one of the Cent Suisses. With him the practice of art seems to have come into the family, together with fortune; he died single and left some money to his nephew Johannes (1763-1840), his brother Jan's son.

Johannes was at first a gold-wire drawer like his father, but he later became a Bible teacher and a clerk in the Cloister Church at The Hague. He married Johanna van der Vin of Malines, and their son Vincent (1789-1874) was enabled, by the legacy of his great-uncle Vincent, to study theology at the University of Leiden. This Vincent, the grandfather of the painter, was a man of great intellect, with an extraordinarily strong sense of duty. At the Latin school he distinguished himself and won all kinds of prizes and testimonials. 'The diligent and studious youth, Vincent van Gogh, fully deserves to be set up as an example to his fellow students for his good behaviour as well as for his persistent zeal,' declared

the rector of the school, Mr. de Booy, in 1805. He finished his studies at the University of Leiden successfully, and graduated in 1811 at the age of twenty-two. He had many friends, and his *album amicorum* preserves their memory in Latin and Greek verse. A little silk-embroidered wreath of violets and forget-me-nots – signed, *E. H. Vrydag 1810* – was wrought by the girl who became his wife as soon as he secured the living of Benschop. They lived long and happily together, first at the parsonage of Benschop, then at Ochten, and from 1822 at Breda, where his wife died in 1875, and where he remained until his death, a highly respected and esteemed man.

Twelve children were born to them, of whom one died in infancy. There was a warm, cordial family feeling, and however far the children drifted apart in the world, they remained deeply attached and shared each other's fortunes and misfortunes. Two of the daughters married officers in high positions, the Generals Pompe and 's Graeuwen; the other three remained single.

All six sons occupied honourable positions in the world. Johannes went to sea and reached the highest rank in the Navy, that of Vice-Admiral; his nephew Vincent lived at his house for a time in 1877, while he was Commandant of the Navy Yard at Amsterdam.

Three sons became art dealers; the eldest, Hendrik
Vincent – 'Uncle Hein,' as he was called in the letters
– first had his business in Rotterdam and later settled
in Brussels. Cornelius Marinus became the head of
the firm C. M. van Gogh, so well known in
Amsterdam. His nephews often called him by his ini-
tials, C. M. The third, who had the greatest influence
on the lives of his nephews Vincent and Theo, was
Vincent. In his youth his health had been too weak for
him to go to college, to the deep regret of his father,
who had the greatest expectations for him. He opened
a little shop in The Hague where he sold colours and
drawing materials, and which he enlarged in a few
years to an art gallery of European renown. He was
an extraordinarily gifted, witty, and intelligent man,
and had great influence in the world of art of that
time. Goupil in Paris offered him a partnership in his
firm, which achieved its highest renown only after Van
Gogh joined it. He settled in Paris, and Mr. Tersteeg
took his place as head of the firm in The Hague,
where Vincent and Theo got their first training in
business. Goupil was 'the house' that played such a
large part in their lives and where Theo remained and
made a successful career. Vincent worked at Goupil's
for six years; in spite of everything, his heart clung to
it because in his youth it had been to him 'finest, the

best, the biggest in the world' (letter 332).

Only one of parson Van Gogh's six sons chose his father's profession. Theodorus (1822–1885) studied theology at Utrecht, graduated, and in 1849 secured the living of Groot-Zundert, a little village in Brabant on the Belgian frontier, where he was confirmed by his father. Theodorus van Gogh was a man of prepossessing appearance ('the handsome dominie' he was called by some), with a loving nature and fine spiritual qualities; but he was not a gifted preacher, and for twenty years he lived forgotten in the little village of Zundert before he was called to other places, and even then only to small villages like Etten, Helvoirt, and Nuenen. But in his small circle he was warmly loved and respected, and his children idolized him.

In May 1851, he married Anna Cornelia Carbentus, who was born in 1819 at The Hague, where her father, Willem Carbentus, was a bookbinder. He had bound the first Constitution of Holland, thereby earning the title of 'bookbinder to the King.' His youngest daughter, Cornelia, was already married to Vincent van Gogh, the art dealer; his eldest daughter was the wife of the well-known Amsterdam clergyman, Stricker. The married life of Theodorus van Gogh and Anna Carbentus was very happy. In his wife he found a helpmate who shared in

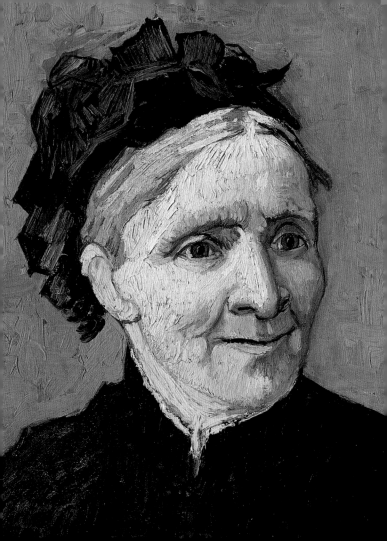

his work with all her heart. Notwithstanding her own family and the work which it entailed, she visited his parishioners with him; and her cheerful, lively spirit was never damped by the monotony of the quiet village life. She was a remarkable, lovable woman, who in her old age (she reached her eighty-seventh year), after having lost her husband and three grown sons, still retained her energy and spirit and bore her sorrow with rare courage.

One of her qualities, next to her deep love of nature, was the great facility with which she could express her thoughts on paper: her busy hands, which were always working for others, grasped eagerly, not only needle and knitting needle, but also the pen. 'I just send you a little word' was one of her favourite expressions, and how many of these 'little words' came just in time to bring comfort and strength to those whom they were addressed to. For almost twenty years they have been to me a never-failing source of hope and courage, and in this book which is a monument to her sons, a word of grateful remembrance is due to their mother.

On March 30, 1852, a dead son was born at the vicarage of Zundert, but a year after on the same date

Opposite: Anna Cornelia Carbentus-van Gogh, 1888

35

Anna van Gogh gave birth to a healthy boy who was called Vincent Willem after his two grandfathers, and who, in qualities and character as well as in appearance, took after his mother more than his father. The energy and unbroken strength of will which Vincent showed in his life were, in principle, his mother's traits; from her also he took the sharp, inquisitive glance of the eye from under the protruding eyebrows. The blond complexion of both the parents became reddish in Vincent; he was of medium height, rather broad-shouldered, and gave the impression of being strong and sturdy. This is also confirmed by his mother's words, that none of the children except Vincent were very strong. A weaker constitution than his would certainly have broken down much sooner under the heavy strain Vincent put upon it.

As a child he was of a difficult temper, often troublesome and self-willed; his upbringing was not fitted to counterbalance these faults, as the parents were very tender-hearted, especially toward their eldest. Once Grandmother Van Gogh, who had come from Breda to visit her children at Zundert, witnessed one of little Vincent's naughty fits. Having learned from experience with her own twelve babies, she took the little culprit by the arm and, with a sound box on the

ears, put him out of the room. The tender-hearted mother was so indignant at this that she did not speak to her mother-in-law for a whole day, and only the sweet-tempered character of the young father succeeded in bringing about a reconciliation. In the evening he had a little carriage brought around, and drove the two women to the heath where, under the influence of a beautiful sunset, they forgave each other.

Little Vincent had a great love for animals and flowers, and made all kinds of collections. There was as yet no sign of any extraordinary gift for drawing; it was only noted that at the age of eight he once modelled a little clay elephant that drew his parents' attention, but he destroyed it at once when, according to his notion, such a fuss was made about it. The same fate befell a very curious drawing of a cat, which his mother always remembered. For a short time he attended the village school, but his parents found that the intercourse with the peasant boys made him too rough, so a governess was sought for the children of the vicarage, whose number had meanwhile increased to six. Two years after Vincent a little daughter had been born, and two years later, May 1, 1857, came a son who was named after his father. After him came two sisters and a little brother. (The younger sister, Willemien, who always lived with her

mother, was the only one to whom Vincent wrote on rare occasions.) Theo was more tender and kind than his brother, who was four years older. He was more delicately built and his features were more refined, but he had the same reddish fair complexion and the same light blue eyes which sometimes darkened to a greenish-blue.

In letter 338 Vincent himself described the similarity and the difference in their looks. In 1889 Theo wrote to me about Rodin's marble head of John the Baptist: 'The sculptor has conceived an image of the precursor of Christ that exactly resembles Vincent. Yet he never saw him. That expression of sorrow, that forehead disfigured by deep furrows which denotes high thinking and iron self-discipline, is Vincent's, though his is somewhat more sloping; the shape of the nose and structure of the head are the same.' When I later saw the bust, I found in it a perfect resemblance to Theo.

The two brothers were strongly attached to each other from childhood, whereas the eldest sister, recalling their childhood, spoke of Vincent's teasing ways. Theo remembered only that Vincent could invent such delightful games that once they made him a present of the most beautiful rosebush in their garden to show their gratitude. Their childhood was full of

the poetry of Brabant country life; they grew up among the wheatfields, the heath and the pine forests, in that peculiar sphere of a village parsonage, the charm of which remained with them all their lives. It was not perhaps the best training to fit them for the hard struggle that awaited them both; they were still so very young when they had to go out into the world, and during the years following, with what bitter melancholy and inexpressible homesickness did they long for the sweet home in the little village on the heath.

Vincent came back there several times, and always appeared the 'country boor'; Theo, who had become quite a refined Parisian, also kept in his heart something of the 'Brabant boy,' as he laughingly liked to call himself.

As Vincent once rightly observed, 'There will always remain in us something of the Brabant fields and heath.' When their father had died and their mother had to leave Brabant, he complained, 'It will be a strange feeling to think that none of us has stayed in Brabant.' Later, when the faithful brother visited him in the hospital of Arles and in tender pity laid his head on the pillow beside him, Vincent whispered,

Overleaf: Marsh with water-lilies, 1881

'Just like Zundert.' Shortly afterward he wrote, 'During my illness I saw again every room in the house at Zundert, every path, every plant in the garden, the view of the fields outside, the neighbours, the graveyard, the church, our kitchen garden at the back – down to a magpie's nest in a tall acacia in the graveyard' (letter 573). So ineffaceable were those first sunny childhood's recollections.

When Vincent was twelve years old he was sent to Mr. Provily's boarding school in Zevenbergen; about this period not a single particular has been found, except that one of the sisters wrote to Theo, 'Do you remember how on Mother's birthday Vincent used to come from Zevenbergen and what fun we had then?' Nothing is known of friends in that time.

When he was sixteen years old, the choice of a profession became urgent, and Uncle Vincent was consulted about this.

The latter, who meanwhile had acquired a large fortune as an art dealer, had been obliged by his feeble health to retire early from the strenuous business life in Paris – though still financially connected with the firm. He had settled at Prinsenhage, near his old father in Breda and his favorite brother in Zundert. Generally he passed the winter with his wife at Menton in the South of France, and on his journey thither he always

stayed some time in Paris, so that he remained in touch with the business. His beautiful country house at Prinsenhage had been enlarged by a gallery for his rare picture collection, and it was here that Vincent and Theo received their first impressions of the world of art. There was a warm, cordial intercourse between the Zundert parsonage and the childless home at Prinsenhage. 'The carriage' from there was always loudly cheered by the children at Zundert, for it brought many surprises – flowers, rare fruits and delicacies; on the other hand, the bright, lively presence of the brother and sister from Zundert often cast a cheerful sunbeam on the life of the patient at Prinsenhage. These brothers, also called Vincent and Theo, differed but one year in age; they were thoroughly attached to each other, and their wives being sisters strengthened the bonds between them. What was more natural than that the rich art dealer destined the young nephew who bore his name to be his successor in the firm – perhaps even to become his heir?

Thus in 1869 Vincent entered the house of Goupil & Co., at The Hague, as the youngest employee under the direction of Mr. Tersteeg. His future seemed bright. He boarded with the Roos family on the Beestenmarkt, where Theo later lived also. It was a comfortable home where his material needs were

perfectly provided for, but there was no intellectual intercourse. This he found with various relations and friends of his mother's, whom he often visited: the Haanebeeks, the Van Stockums, and Aunt Sophie Carbentus and her three daughters. One of the latter married our famous Dutch painter, A. Mauve; a second, the less known painter, A. le Comte. Tersteeg sent the parents good reports about Vincent's zeal and capacities, and like his grandfather in his time, he was 'the diligent, studious youth' whom everybody liked.

When he had been at The Hague for three years, Theo, who was still at school at Oisterwijk (near Helvoirt, to which village their father had been called), came to stay with him for a few days. It was after that visit in August 1872, that the correspondence between the two brothers began, and from this now faded, yellow, almost childish little note it is carried on uninterruptedly until Vincent's death, when a half-finished letter to Theo was found on him. The desponding '*que veux-tu?*' at the end seems like the gesture of resignation with which he parted from life.

The principal events of both their lives are mentioned in the letters and are completed in this biographical notice by particulars, either heard from Theo himself, or found in the correspondence of the

parents with Theo, also preserved in full. (Vincent's letters to his parents were unfortunately destroyed.) They date from January 1873, when Theo, only fifteen years old, went to Brussels to be apprenticed as an art dealer also. These letters are full of the tenderest love and care for the boy who left home so young. 'Well, Theo, you are quite a man now at fifteen,' said his mother in one of her letters. They clung fondly to him because he more than any of the other children repaid their love with never-failing tenderness and devotion, and grew up to be, as they so often said, 'the crowning glory of their old age.' The letters tell of all the small events of daily life at the parsonage; what flowers were growing in the garden, and how the fruit trees bore, if the nightingale had been heard yet, what visitors had come, what the little sisters and brother were doing, what the text of Father's sermon was, and among all this, many particulars about Vincent.

In 1873 the latter had been transferred to the firm in London. When leaving The Hague, he got a splendid testimonial from Mr. Tersteeg, who also wrote to the parents that at the gallery everybody liked to deal with Vincent – art lovers, clients, as well as painters – and that he certainly would succeed in his profession.

Overleaf: Bleaching ground at Scheveningen, near The Hague, July 1882

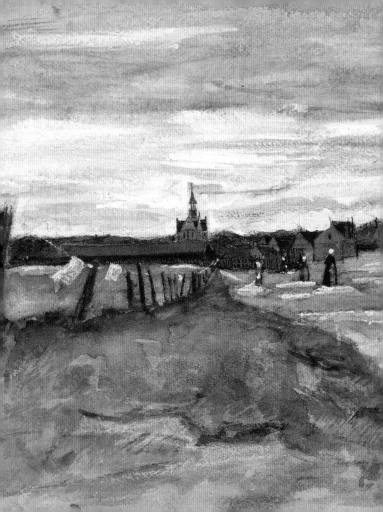

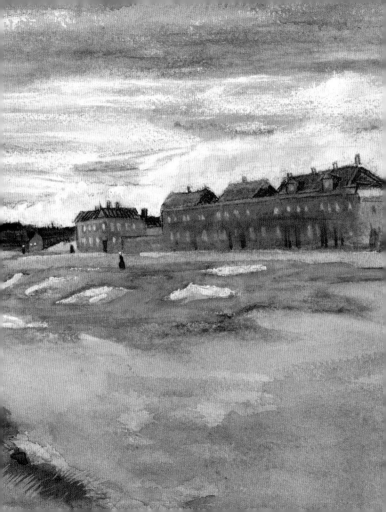

'It is a great satisfaction that he can close the first period of his career in that way, and withal he has remained just as simple as he was before,' wrote Mother. At first everything went well with him in London; Uncle Vincent had given him introductions to some of his friends, and he threw himself into his work with great pleasure. He earned a salary of £90 a year, and though the cost of living was high, he managed to lay by some money to send home now and then. He bought himself a top hat like a real businessman – 'You cannot be in London without one' – and he enjoyed his daily trips from the suburbs to the gallery on Southampton Street in the city.

The first boardinghouse he stayed in was kept by two ladies who owned two parrots. The place was nice, but somewhat expensive; therefore, he moved in August to the house of Mrs. Loyer, a curate's widow from the south of France, who with her daughter Ursula ran a day school for little children. There he spent the happiest year of his life. Ursula made a deep impression upon him. 'I never saw or dreamed of anything like the love between her and her mother,' he wrote to one of his sisters; and, 'Love her for my sake.'

He did not mention it to his parents, for he had not even confessed his love to Ursula herself – but his letters home were radiant with happiness. He wrote that

48

he enjoyed his life so much – 'Oh fullness of rich life, your gift O God.'*

In September an acquaintance was going over to London and undertook to bring a parcel for Vincent. Characteristically, it contained, among other things, a bunch of grass and a wreath of oak leaves made at home during the holidays by Theo, who had meanwhile been transferred from Brussels to the House of Goupil at The Hague. Vincent had to have something in his room to remind him of the beloved fields and woods.

He celebrated a happy Christmas with the Loyers. He would send home now and then a little drawing, from his house and the street and from the interior of his room, 'so that we can imagine exactly how it looks, it is so well drawn,' wrote his mother. In this period he seems to have weighed the possibility of becoming a painter; later he wrote to Theo from Drenthe, '... how often I stood drawing on the Thames Embankment, on my way home from Southampton Street in the evening and it came to nothing. If there had been somebody then to tell me what perspective was, how much misery I should have been spared, how much further I should be now!'

* First line of a well-known Dutch poem.

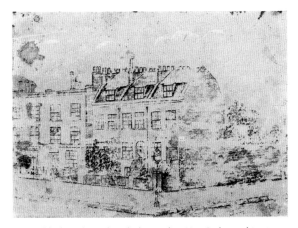

87 Hackford Road, London: the house where Van Gogh stayed in 1873 and 1874

At that time he occasionally met Matthijs Maris,* but was too bashful to speak out freely to him and shut all his longings and desires within himself – he still had a long road of sorrow to go before he could reach his goal.

In January his salary was raised, and until spring his letters remained cheerful and happy. He intended to visit Holland in July, and before that time he

* Famous Dutch painter, living in London

apparently spoke to Ursula of his love. Alas, it turned out that she was already engaged to the man who boarded with them before Vincent came. He tried everything to make her break this engagement, but he did not succeed.

With this first great sorrow his character changed; when he came home for the holidays he was thin, silent, dejected – a different being. But he drew a great deal. Mother wrote, 'Vincent made many a nice drawing: he drew the bedroom window and the front door, all that part of the house, and also a large sketch of the houses in London which his window looks out on; it is a delightful talent which can be of great value to him.'

Accompanied by his eldest sister, who wanted to find a situation, he returned to London. He took furnished rooms in Ivy Cottage, 39 Kensington New Road; there, without any family life, he grew more and more silent and depressed, and also more and more religious.

His parents were glad he left the Loyers. 'His living at the Loyers' with all those secrets has done him no good, and it was not a family like others ... but not realizing his hopes must have been a great disappointment to him,' Father wrote. Mother complained, 'The evenings are so long already and his

work finishes early; he must be lonely. If only it does not harm him.'

They felt uneasy and worried about his solitary, secluded life. Uncle Vincent also insisted on his mixing more with other people: 'That is just as necessary as learning your business.' But the depression continued. Letters home grew more and more scarce, and Mother began to think that the London fog depressed him and that even a temporary change might do him good: 'Poor boy, he means so well, but I believe things are very hard for him just now.'

In October 1874, Uncle Vincent did indeed effect a short removal to the firm in Paris. Vincent himself was little pleased by this, in fact, he was so angry that he did not write home, to the great grief of his parents. 'He is only in a bad temper,' his sister said; and Theo comforted, 'He is doing all right.'

Toward the end of December he returned to London, where he took the same rooms and led the same solitary life. For the first time he was described as eccentric. His love for drawing had ceased, but he read a great deal. The quotation from Renan which closes the London period clearly shows what filled his thoughts and how high he aimed even then: '... to sacrifice all personal desires ... to realize great things ... to attain nobility and to surmount the vulgarity of

nearly every individual's existence.' He did not know yet how to reach his goal.

In May 1875, he was transferred permanently to Paris and assigned especially to the picture gallery, where he felt quite out of place. He was more at home in his 'cabin,' the little room in Montmartre where, morning and evening, he read the Bible with his young friend, Harry Gladwell, than among the worldly Parisian public.

His parents inferred from his letters that things were not going well. After he had come home at Christmas and everything had been talked over, Father wrote to Theo, 'I almost think that Vincent had better leave Goupil within two or three months; there is so much that is good in him, yet it may be necessary for him to change his position. He is certainly not happy.' And they loved him too much to persuade him to stay in a place where he would be unhappy. He wanted to live for others, to be useful, to bring about something great; he did not yet know how, but not in an art gallery. On his return from Holland he had a decisive interview with Mr. Boussod (the son-in-law and successor of Mr. Goupil) that ended in his dismissal as from April 1, and he accepted it without offering any excuses for himself. One of the grievances against him was that he had gone home to

Holland for Christmas and New Year's, the busiest time for business in Paris.

In his letters he seemed to take it rather lightly, but he felt how gloomily and threateningly the clouds were beginning to gather around him. At the age of twenty-three he had been thrown out of employment, without any chance of a better career; Uncle Vincent was deeply disappointed in his namesake and had washed his hands of him; his parents were well-meaning, but they could not do much for him, as they had been obliged to touch their capital for the education of their children. (The pastor's salary was about 820 guilders a year.) Vincent had had his share, now the others had to have theirs. It seemed that Theo, who was soon to become everybody's helper and adviser, had already at that time suggested Vincent's becoming a painter; but for the moment he would not hear of it. His father suggested a position in a museum or opening a small art gallery for himself, as Uncle Vincent and Uncle Cor had done before him; he would have then been able to follow his own ideas about art and have been no longer obliged to sell pictures which he considered bad. But his heart again drew him to England, and he planned to become a teacher.

Through an advertisement, in April 1876, he got a

position in Ramsgate at Mr. Stokes's, whose school moved in July to Isleworth. He received only board and lodging, no salary. He soon accepted another position at the somewhat richer school of Mr. Jones, a Methodist preacher, where Vincent finally acted as a kind of curate.

His letters home were gloomy. 'It seems as if something were threatening me,' he wrote. His parents perceived full well that teaching did not satisfy him. They suggested his studying for a French or German college certificate, but he would not hear of it. 'I wish he could find some work in connection with art or nature,' wrote his mother, who understood what was going on within him. With the force of despair he clung to religion, in which he tried to satisfy his craving for beauty as well as his longing to live for others. At times he seemed to become intoxicated with the sweet, melodious words of the English texts and hymns, the romantic charm of the little village church, and the lovely, holy atmosphere that enveloped the English service. His letters in those days contained an almost morbid sensitivity. Over and over he spoke about a position connected with the church – but when he came home for Christmas, it was decided that he would not go back to Isleworth because there was absolutely no prospect for the

future. He remained on friendly terms with Mr. Jones, who later came to stay a few days at the Etten parsonage, and whom he subsequently met in Belgium.

Once again Uncle Vincent used his influence and procured a place for him in the bookshop of Blussé and Van Braam in Dordrecht. He accepted it, but without great enthusiasm. The words written to Theo by one of the sisters were characteristic: 'You think that he is something more than an ordinary human being, but I think it would be much better if he thought himself just an ordinary being.' Another sister wrote, 'His religion makes him absolutely dull and unsociable.'

To preach the Gospel still seemed to him the only desirable thing, and at last an attempt was made to enable him to begin the study of theology. The uncles in Amsterdam promised to give their aid. He could live with Uncle Jan van Gogh, Commandant of the Navy Yard, which would be a great saving; Uncle Stricker found the best teacher in the classical languages, the well-known Dr. Mendes da Costa, and gave Vincent some lessons himself; he could satisfy his love for pictures and prints in Uncle Cor's art gallery. Everybody tried to make it easy for him, all except Uncle Vincent, who was strongly opposed to the plan and would not help promote it – in which he proved

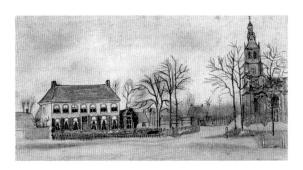

Vicarage and church at Etten, 1876

to be right after all. Vincent set to work full of courage; first, he had to prepare himself for a State examination before he could be admitted to the university, and then it would take seven years to become fully qualified. His parents anxiously asked themselves whether he would have the strength to persevere, and whether he, who had never been used to regular study, would be able to force himself to it at the age of twenty-four.

That period in Amsterdam, from May 1877 to 1878, was one long tale of woe. After the first half year Vincent began to lose ardour and courage. Writing exercises and studying grammar were not what he wanted to do; he wanted to comfort and

cheer people by bringing them the Gospel – and sure-
ly he did not need so much learning for that! He real-
ly longed for practical work, and when at last his
teacher also perceived that Vincent would never suc-
ceed, he advised him to give up his studies. In the
Handelsblad of December 2, 1910, Dr. Mendes da
Costa wrote his personal recollections of the pupil
who later became so famous. He recorded many
characteristic particulars: Vincent's nervous, strange
appearance that yet was not without charm; his fer-
vent intention to study well; his peculiar habit of self-
discipline, self-chastisement; and finally, his total
unfitness for regular study. Not along that path was he
to reach his goal! He confessed openly that he was
glad things had gone so far and that he could look for-
ward to his future with more courage than when he
devoted himself hopelessly to his theological studies,
which period he afterward called 'the worst time of
my life.'

He would remain 'humble,' and now wanted to
become an evangelist in Belgium; for this no certifi-
cates were required, no Latin or Greek – only three
months at the School of Evangelization at Brussels.
There the lessons were free, the only charges being
board and lodging, and he could get his nomina-
tion. In July he travelled thither with his father,

accompanied by Mr. Jones, who on his way to Belgium had spent a few days with them at Etten. Together they visited the members of the Committee of Evangelization: the Reverend Mr. Van den Brink from Rousselaere; the Reverend Mr. Pietersen from Malines; and the Reverend Mr. De Jong from Brussels. Vincent explained his case clearly and made a very good impression. His father wrote: 'His stay abroad and that last year at Amsterdam have not been quite fruitless after all, and when he takes the trouble to exert himself, he shows that he has learned and observed much in the school of life.' Vincent consequently was accepted as a pupil.

But the parents regarded this new experiment with fresh anxiety: 'I am always so afraid that wherever Vincent may be or whatever he may do, he will spoil everything by his eccentricity, his queer ideas and views on life,' his mother wrote. His father added, 'It grieves us so to see that he literally knows no joy of life, but always walks with bent head, whilst we did all in our power to bring him to an honourable position! It seems as if he deliberately chooses the most difficult path.'

In fact, that was Vincent's aim – to humble himself, to forget himself, to sacrifice himself, *mourir à soi-même* (to renounce his own feelings and needs) – that was

the severe ideal he tried to reach as long as he sought his refuge in religion, and he never did a thing by halves. But to follow the paths trodden by others, to submit to the will of other people, that was not in his character; he wanted to work out his own salvation. Toward the end of August be arrived at the school in Brussels which had been opened only recently and had but three pupils. He certainly was the most advanced in Mr. Bokma's class, but he did not feel at home at the school, he was 'like a fish out of water,' he said, and was ridiculed for his peculiarities in dress and manners. He also lacked the ability to extemporize, and was therefore obliged to read his lectures from manuscript. But the greatest objection against him was, 'He is not submissive'; and when the three months had elapsed, he did not get his nomination. Though he wrote (in letter 126) in an offhand way to Theo, he seems to have been greatly upset by it. His father received a letter from Brussels, probably from the school, saying that Vincent was weak and thin, did not sleep, and was in a nervous and excited state, so that it would be best to come and take him home.

He immediately travelled to Brussels and succeeded in arranging everything. At his own risk Vincent went to the Borinage, where he boarded at 30 francs a month with M. Van der Haegen, Rue de L'Église 39,

at Pâturages near Mons. He taught the children in the evening, visited the poor, and held Bible classes; when the Committee met in January, he would again try to get a nomination. The intercourse with the people pleased him very much, and in his leisure hours he drew large maps of Palestine, of which his father ordered four at 10 francs apiece. At last, in January 1879, he got a temporary nomination for six months at Wasmes at 50 francs a month, for which he would have to give Bible classes, teach the children, and visit the sick – the work of his heart. His first letters from there were very contented, and he devoted himself heart and soul to his work, especially the practical part of it; his greatest interest was in nursing the sick and wounded. Soon, however, he fell back into the old exaggerations – he tried to practice the doctrines of Jesus, giving away everything – his money, clothes and bed – leaving the good Denis boarding-house in Wasmes, and retiring to a miserable hut where every comfort was wanting. Already his parents had been notified of it, and when, toward the end of February, the Reverend Mr. Rochelieu came for inspection, the bomb exploded. So much zeal was too much for the Committee, and a person who neglected himself so could not be an example to others. The Church Council at Wasmes held a meeting, and it agreed that

if he did not listen to reason, he would lose his position. He himself took it rather coolly. 'What shall we do now?' he wrote. 'Jesus was also very calm in the storm; perhaps it must grow worse before it grows better.' Again his father went to him and succeeded in stilling the storm; he brought him back to the old boarding-house and advised him to be less exaggerated in his work.

For some time everything was all right, at least he wrote that there were no complaints. About that time a heavy mine explosion occurred and a strike broke out, so Vincent could devote himself completely to the miners. In her naïve religious faith his mother wrote, 'Vincent's letters, which contain so many interesting things, prove that with all his peculiarities, he yet shows a warm interest in the poor; that surely will not remain unobserved by God.' During that same period he also wrote that he had tried to sketch the dresses and tools of the miners and would show them when he came home. In July bad tidings came again. 'He does not comply with the wishes of the Committee, and nothing will change him. It seems that he is deaf to all remarks that are made to him,' wrote his mother. When the six months of probation

Opposite: Coal shoveller, Cuesmes, 1879

had passed, he was not appointed again, but was given three months to look for another position.

He left Wasmes and traveled on foot to Brussels to ask the Reverend Mr. Pietersen, who had moved there from Malines, for advice. The latter painted in his leisure hours and had a studio, which was probably why Vincent went to him for help. He arrived there tired and hot, exhausted and in a nervous condition; his appearance was so neglected that the daughter of the house who opened the door was frightened, called for her father and ran away. The Reverend Mr. Pietersen received him kindly; he procured him good lodgings for the night, invited him to his table the next day, showed him the studio, and as Vincent had brought some of his sketches of the miners, they probably talked as much about drawing and painting as about evangelization.

'Vincent impresses me as somebody who stands in his own light,' wrote the Reverend Mr. Pietersen to Vincent's parents.

Mother replies, 'How lucky it is that he still always finds somebody who helps him on, as the Reverend Mr. Pietersen has now.'

In accordance with the latter's advice, Vincent resolved to stay in the Borinage at his own expense, as he could not do so in the service of the Committee,

and board with the Evangelist Frank, in Cuesmes. About the middle of August, at their request, he visited his parents again at Etten. 'He looks well, except for his clothes. He reads Dickens all day and speaks only when he is spoken to; about his future, not a single word,' wrote his mother. What could he say about his future? Did it ever look more hopeless than it did now? His illusion of bringing comfort and cheer into the miserable lives of the miners through the Gospel had gradually been lost in the bitter struggle between doubt and religion which took place within him at that time, and which made him lose his former faith in God. (The Bible texts and religious reflections, which had become more and more rare in his last letters, stopped entirely.) Nothing else had taken its place yet. He drew and read a great deal – among others Dickens, Beecher Stowe, Victor Hugo, and Michelet – but it was all done without system or purpose. Back in the Borinage he wandered about without work, without friends and very often without bread; for though he received money from home and from Theo, they could not give him more than was strictly necessary, and as it came very irregularly and Vincent was a very poor financier, there were days, even weeks, when he was quite without money.

In October Theo, who had secured a permanent

position at Goupil's in Paris, visited him on his journey thither and tried in vain to induce him to adopt some fixed plan for the future. He was not yet ready to make any decision; before he became conscious of his real power, he was to struggle through the awful winter of 1879-80, that saddest, most hopeless time of his never very fortunate life. It was during these days that he undertook, with 10 francs in his pocket, the hopeless expedition to Courrières, the dwelling place of Jules Breton, whose pictures and poems he so much admired, and with whom he secretly hoped to come into contact in some way or other. But all he saw was the inhospitable exterior of Breton's newly built studio; he lacked the courage to introduce himself. Disappointed, his money spent, he made the long journey home; mostly he slept either in the open air or in a hayloft. Sometimes he exchanged a drawing for a piece of bread, but he suffered so much fatigue and want that his health never fully recovered.

In spring he returned to the vicarage of Etten and spoke again about going to London. 'If he really wants to, I shall help him go,' wrote his father. But finally he went back to the Borinage, and that summer of 1880 he lived in the house of the miner Charles Decrucq at Cuesmes. There he wrote in July the wonderfully touching letter (133) which tells what

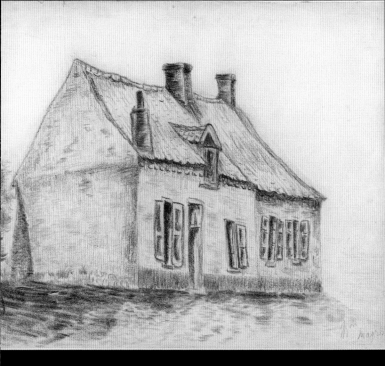

House at Cuesmes, 1879

is going on in his innermost self, '... my only anxiety is, how can I be of use?... Can't I serve some purpose and be of any good?' It is the old wish, the old longing to serve and comfort humanity, which made him write later, when he had found his calling, 'And in a picture I want to say something comforting as music is comforting.' Now, in the days of deepest discouragement and darkness, at last the light began to dawn. Not in books would he find satisfaction, nor find his work in literature, as his letters sometimes suggested; he turned back to his old love, 'I said to myself ... I will take up my pencil ... I will go on with my drawing. From that moment everything has seemed transformed for me ...' It sounds like a cry of deliverance, and once more, '... do not fear for me. If I can only continue to work ... it will set me right again.' At last he had found his work, and his mental equilibrium was restored; he no longer doubted himself, and however difficult or hard his life became, the inner serenity, the conviction of having found his own calling, never deserted him again.

The little room in the house of the miner Decrucq, which he had to share with the children, was his first studio. There he began his painter's career with the first original drawings of miners going to work in the early morning. There he copied with restless activity

the large drawings after Millet, and when the room got too narrow for him, he took his work out into the garden.

When the cold autumn weather prevented this, and because his surroundings at Cuesmes were getting too cramped for him, he moved in October to Brussels, where he settled in a small hotel at 72 Bd. du Midi. He was longing to see pictures again, but above all he hoped to become acquainted with other artists.

Deep in his heart there was such a great longing for sympathy, for kindness and friendship, and though his difficult character generally prevented him from finding this and left him isolated in life, yet he always kept on longing for somebody with whom he could live and work.

Theo, who meanwhile had acquired a good position in Paris, could now assist him in word and deed. He brought Vincent into contact with the young Dutch painter Van Rappard, who had worked some time in Paris and was then studying at the academy in Brussels. At first the acquaintance did not progress, for the outward difference between the rich young nobleman and the neglected wanderer from the Borinage was too great; yet the artistic taste and opinions

Overleaf: Women carrying coal, 1882

of both were too similar for them not to find each other eventually. A friendship arose – perhaps the only one that Vincent ever had in Holland; it lasted for five years and then was broken through a misunderstanding which Van Rappard always regretted, though he acknowledged that intercourse with Vincent was very difficult.

'I remember as if it happened yesterday the moment of our first meeting at Brussels when he came into my room at nine o'clock in the morning, how at first we did not get on very well together, but so much the better after we had worked together a few times,' wrote Van Rappard to Vincent's mother after his death. And again, 'Whoever had witnessed this wrestling, struggling and sorrowful existence could not but feel sympathy for the man who demanded so much of himself that it ruined body and mind. He belonged to the breed that produces the great artists.

'Though Vincent and I had been separated the last years by a misunderstanding which I have often regretted – I have never ceased to remember him and the time we spent together with great sympathy.

'Whenever in the future I shall remember that time, and it is always a delight for me to recall the past, the characteristic figure of Vincent will appear

to me in such a melancholy but clear light, the strug-
gling and wrestling, fanatic, gloomy Vincent, who
used to flare up so often and was so irritable, but who
still deserved friendship and admiration for his noble
mind and high artistic qualities.'

Vincent's own opinion of Van Rappard is clearly
shown in his letters. A second acquaintance that
Vincent made through Theo, with the painter
Roelofs, was of lesser importance. Vincent did not
take Roelofs' advice to enter the academy; perhaps he
was not admitted because he was not far enough
advanced, but probably he had more than enough of
academical institutions and theories. In painting as
well as in theology he preferred to do his own way;
that is why he did not come into contact with other
Dutch painters who were at that same time at the
Brussels Academy, for instance, Haverman.

He studied anatomy by himself, drew diligently
from living models, and from a letter to his father it
seems that he took lessons in perspective from a poor
painter at 1.50 francs for a two hour lesson; it has not
been possible to ascertain the name of the painter, but
it may have been Madiol.

At the end of the winter, with the departure of Van

Overleaf: Road in Etten, 1881

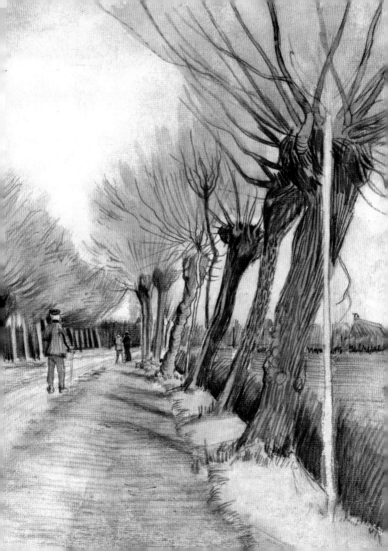

Rappard, in whose studio he had often worked because his own little bedroom was too small, he longed for other surroundings, especially for the country. Expenses in Brussels were also somewhat heavy, and he thought it would be cheapest to go to his parents in Etten, where he had board and lodging free and could use all the money he received for his work.

He stayed there for eight months, and the summer of 1881 was again a happy time for him. First, Van Rappard came to visit him, and he too always remembered with pleasure his stay at the vicarage. 'And my visit to Etten! I can still see you sitting at the window when I came in,' he wrote to Vincent's mother in the letter quoted above. 'I still enjoy the beautiful walk we all took together that first evening, through the fields and along the small path! Our excursions to Seppen, Passievaart, Liesbosch – I often look through my sketchbooks for them.'

In the beginning of August Theo came over from Paris. Shortly after, Vincent made a trip to The Hague to consult Mauve about his work; the latter firmly encouraged him so that he continued with great animation. Finally, in those days he met for the second time a woman who had great influence on his life. Among the guests who spent that summer at the vicarage at Etten was a cousin from Amsterdam – a

young widow with her little four-year-old son. Quite absorbed in her grief over the loss of her husband, whom she had loved so tenderly, she was unconscious of the impression which her beauty and touching sorrow made on the cousin who was a few years her junior. 'He was so kind to my little boy,' she said when she later remembered that time. Vincent, who was very fond of children, tried to win the mother's heart by great devotion to the child. They walked and talked much together, and he also drew a portrait of her (which seems to have been lost). The thought of a more intimate relation did not occur to her, and when Vincent at last spoke to her of his love, a very decided no was the immediate reply. She went back to Amsterdam and never saw him again. Vincent could not abide by her decision, and with his innate tenacity he kept on persevering and hoping for a change in her feelings for him. When his letters were not answered, he accused both his and her parents of opposing the match, and only a visit to Amsterdam, where she refused to see him, convinced him of the utter hopelessness of his love.

'He fancied that he loved me,' she said afterward, but for him it was sad earnest, and her refusal became a turning point in his life. If she had returned his love, it would perhaps have spurred him on to acquire a

social position – he would have had to provide for her and her child. As it was he lost all worldly ambition, and subsequently lived only for his work, without taking one step to make himself independent. He could not bear to stay in Etten any longer. He had become irritable and nervous, his relations with his parents became strained, and in December, after a violent altercation with his father, he left suddenly for The Hague.

The two years he spent there were for his work a very important period, of which his letters give a perfect description. His low spirits rose at first with the change of surroundings and the intercourse with Mauve; but the feeling of having been slighted and wronged did not leave him, and he felt utterly abandoned. When in January he met a poor neglected woman approaching her confinement, he took her under his protection, partly from pity but also to fill the great void in his life. 'I hope there is no harm in his so-called model. Bad connections often arise from a feeling of loneliness, of dissatisfaction,' his father wrote to Theo, who was always the confidant of both parties and had to listen to all the complaints and worries. Father was not far from being right. Vincent

Opposite: Orphan Man, standing, 1882

could not be alone; he wanted to live for somebody, he wanted a wife and children, and as the woman he loved had rejected him, he took the first unhappy woman who crossed his path, with children that were not his own. At first he feigned happiness and tried to convince Theo in every letter how wisely and well he had acted; the touching care and tenderness with which he surrounded the woman when she left the hospital after her confinement strike us painfully when we think on whom that treasure of love was lavished. He prided himself now on having a family of his own, but when their living together had become a fact and he was continually associated with a coarse, uneducated woman, marked by smallpox, who spoke with a vulgar accent and had a spiteful character, who was addicted to liquor and smoked cigars, whose past life had not been irreproachable, and who drew him into all kinds of intrigues with her family, he soon wrote no more about his home life. Even the posing, by which she won him (she sat for the beautiful drawing, *Sorrow**) and of which he had expected so much, soon ceased altogether.

This unfortunate liaison deprived him of the

* Walsall Art Gallery

Opposite: Sorrow, 1882

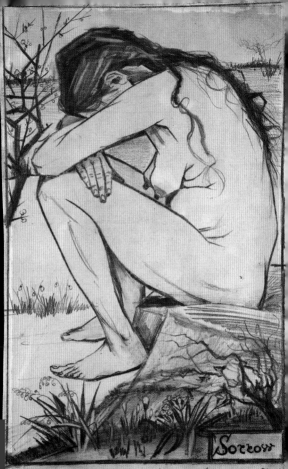

Sorrow

Comment se fait-il qu'il y ait sur la terre une femme seule — délaissée — Michelet

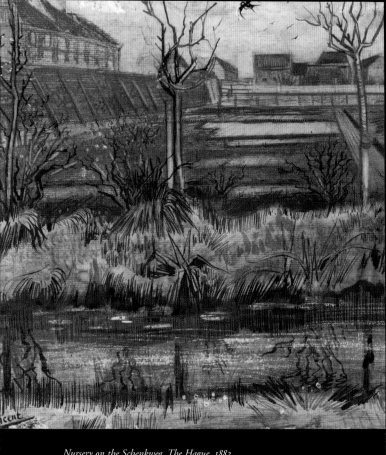

Nursery on the Schenkweg, The Hague, 1882
One of twenty images commissioned from Van Gogh by his uncle
Cornelis Marinus, of which only this one was completed.

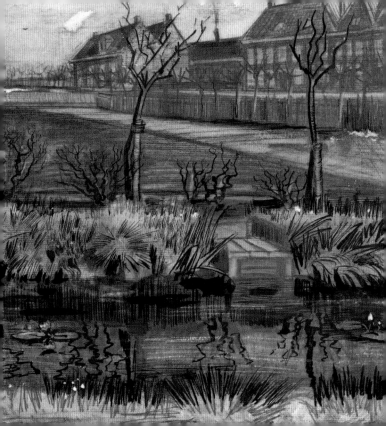

sympathy of all in The Hague who took an interest in him. Neither Mauve nor Tersteeg could approve of his taking upon himself the cares of a family – and such a family! – while he was financially dependent on his younger brother. Acquaintances and relatives were shocked to see him walking about with such a slovenly woman; nobody cared to associate with him any longer, and his home life was such that nobody came to visit him. The solitude around him became greater and greater and, as usual, it was only Theo who understood and continued to help him.

When the latter came to visit Vincent for the second time in The Hague, in the summer of 1883, and saw the situation for himself (he found the household neglected, everything in bad condition and Vincent deeply in debt), he too advised him to let the woman go her own way, as she was not able to live an ordered life. She herself had already realized that things could not continue, because Vincent required too much money for his painting to leave enough for the support of her and the children, and she and her mother were already planning to earn money another way. Vincent himself felt that Theo was right, and in his heart he longed for a change of surroundings and the liberty to go where his work called him; but it cost him a bitter struggle to give up what he had taken upon

himself and to leave the poor woman to her fate. Till the last he defended her and excused her faults with the sublime words, '... she has never seen what is good, how can she be good?'

In those days of inner strife he allowed Theo to read deeper than ever into his heart. These last letters from The Hague (letters 313 to 322) give the key to many things that were incomprehensible until now. For the first time he spoke openly about what had happened at the time of his dismissal from Goupil, explained his strange indifference to showing his own work or trying to make it profitable when he wrote, 'I am so afraid that the steps I might take to introduce myself would do more harm than good ... It is ... so painful for me to speak to people. I am not afraid of it, but I know I make an unfavourable impression.' How naïvely he added, '... human brains cannot beat everything ... Look at Rappard, who got brain fever, and had to travel as far as Germany to recover.' As if he wanted to say, 'Do not let me make efforts to know strangers, as the same thing might happen to me.' Once more he touched on the old love story of Etten. 'A simple word ... made me feel that ... nothing is changed within me in that respect, that it is and

Overleaf: Flower Beds near The Hague, April 1883

remains a wound which I carry with me; it lies deep and cannot be healed. After years it will be the same as it was the first day.' And he expressed openly how different his life would have been without this disappointment in love.

When at last in September he started alone for Drenthe, he had made all possible provisions for the woman and the children. There was a sorrowful parting, especially from the little boy, to whom he had become attached as if to his own child.

The trip to Drenthe proved a failure, instead of doing him any good. But some of his most beautiful letters date from those days. The season was too far advanced, the country too inhospitable, and what Vincent so ardently desired – to come into contact with some artists, for instance, Liebermann – was not realized.

Bitter loneliness and lack of money put too heavy a strain on his nerves. He was afraid of falling ill, and in December 1883, hastened back to the parental vicarage, the only place where he could find a safe shelter.

His father had meanwhile left Etten and been called to Nuenen, a village in the neighbourhood of Eindhoven. The new place and surroundings pleased Vincent so much that instead of paying a short visit,

Two women on the heath, Drenthe, October 1883

as he originally intended, he stayed there for two years. He wanted to paint the Brabant landscape and the Brabant types, and in doing so he ignored every obstacle.

Living with his parents was very difficult for him as well as for them. In a small village vicarage, where nothing can happen without everybody's knowing it, a painter was obviously an anomaly; how much more a painter like Vincent, who had so completely broken with all formalities, conventionalities and with all religion, and who was the last person in the world to conform himself to other people. On both sides there must have been great love and patience for it to have lasted so long.

When his letters from Drenthe to his parents had become more and more melancholy, his father had anxiously written to Theo, 'It seems to me that Vincent is again in a wrong mood. He seems to be in a melancholy state of mind; but how can it be otherwise? Whenever he looks back into the past and recalls how he has broken with all former relations, it must be very painful to him. If he only had the courage to think of the possibility that the cause of much which has resulted from his eccentricity lies in himself. I don't think he ever feels any self-reproach, only spite against others, especially against the gentle-

men in The Hague. We must be very careful with him, for he seems to be in a contrary mood.'

And they were so careful. When he came back to them of his own will, they received him with so much love and tried everything in their power to make him comfortable. They were proud, too, of the progress in his work, of which it must be said they had no great expectations at first. 'Do you not like the pen drawings of the tower that Vincent sent you? It seems to come to him so easily,' wrote his father in the first days of December to Theo. Then on December 20, 'You will be eager to know how Vincent is getting on. At first it seemed hopeless, but by and by things arranged themselves, especially since we approved of his staying here for some time to make studies. He wanted the mangling room fitted up for him, although we did not think it was suitable. We had a nice stove put in; as the room had a stone floor, we had it covered with boards and made it as comfortable as possible: we put in a bed on a wooden stand, so that it might not be too damp. Now we will make the room nice and warm and dry, so that it may turn out better than we expected. I proposed having a large window made in it, but he did not want that. In short, we undertake this experiment with real confidence, and we intend to leave him perfectly free in his peculiarities of dress,

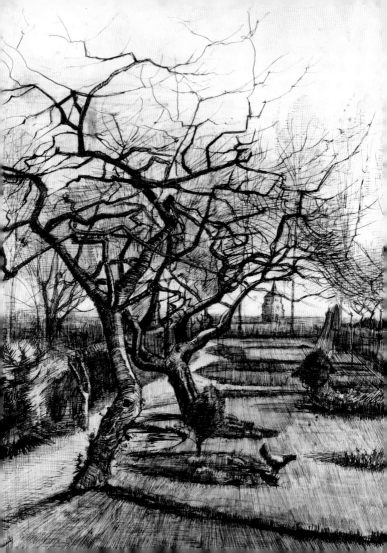

etc. The people here have seen him anyhow, and though it is a pity he is so reserved, we cannot change the fact of his being eccentric...' 'He seems to occupy himself a great deal with your plans for the future, but you will be wise enough not to let yourself be influenced into doing things that are not practical, for alas, that certainly is his foible. One thing is certain, he works hard and finds lots of subjects here; he has already made several drawings which we like very much.'

Such was the feeling from their side; but Vincent was not satisfied with all that kindness and craved a deeper understanding of his innermost self than his parents could give, however much they tried. About the middle of January 1884, when his mother had an accident and was brought home from Helmond with a fractured thighbone, the relations became less strained. Vincent, who had become an expert nurse in the Borinage, helped to nurse his mother with the greatest devotion, and in every letter during that period they praised him for his faithful help. 'Vincent is untiring, and the rest of his time he devotes to his painting and drawing with the greatest zeal.' 'The doctor praised Vincent for his ability and care.'

Opposite: The parsonage garden at Nuenen in winter, 1884

'Vincent proves an ideal nurse and at the same time he works with the greatest ambition.' 'I fervently hope that his efforts may find success, for it is edifying to see how much he works,' stated the February letters.

Vincent's own letters at that time were gloomy and full of complaints and unjust reproaches to Theo that he never sold anything for him and did not even try, ending at last with the bitter cry: 'A wife you cannot give me, a child you cannot give me, work you cannot give me. Money, yes. But what good is it to me if I must do without the rest!' Theo, who always understood him, never gave a sharp or angry answer to those reproaches: a light sarcasm was the only reply he sometimes allowed himself.

In May Vincent's spirits rose somewhat when he moved into a new, larger studio – two rooms in the house of the sexton of the Catholic church. Shortly after, Van Rappard came to spend some time with him again. Besides, during his mother's illness Vincent had increasingly come into contact with neighbours and friends in the village, who daily came to visit the patient, so that he then wrote, 'I have been getting on better with people here than I did at first, which is of great importance to me, for one decidedly needs some distraction, and if one feels too lonely, the work suffers from it.' But he continued prophetically,

'… however, perhaps one must be prepared for it not to last.'

Indeed, difficult times were approaching again. With one of his mother's visitors, the youngest of three sisters who lived next door to the vicarage, he had soon got into a more intimate relation; she was much older than he and neither beautiful nor gifted, but she had an active mind and a kind heart. She often visited the poor with Vincent; they walked much together, and on her part at least the friendship soon changed into love. As to Vincent, though his letters do not give the impression of any passionate feeling for her (the fact is, he wrote very little about it), yet he seemed to have been inclined to marry her. However, the family vehemently protested against the plan, and violent scenes took place between the sisters, which were not conducive to keeping Vincent in a pleasant mood.

'Vincent works hard, but he is not very sociable,' wrote his mother in July. It was to get worse still, for the young woman, violently excited by the scenes with her sisters, tried to commit suicide. She failed, but her health had been so shocked that she had to be nursed at a doctor's in Utrecht. She recovered completely, and after half a year she came back to Nuenen; but their relations were broken forever, and the whole affair left Vincent in a gloomy, bitter mood.

For his parents the consequences were also painful, because the neighbours avoided the vicarage from that time on, not wishing to meet Vincent, 'which is a great privation for me, but it is not your mother's way to complain,' Mother wrote in October of that year. During that period Van Rappard came to stay with them again. 'He is not a talkative person, but a hard worker,' wrote Mother. Van Rappard himself wrote in 1890, in the letter to her quoted above, 'How often I think of the studies of the weavers which he made in Nuenen and the intensity of feeling with which he depicted their lives; what deep melancholy pervaded his work, however clumsy its execution may have been then. And what beautiful studies he made of the old church tower in the churchyard. I always remember a moonlight effect of it which particularly struck me at that time. When I think of those studies in these two rooms near the church, so many memories are conjured up, and I am reminded of all the surroundings – the cheerful, hospitable vicarage with its beautiful garden, the Begemann family, our visits to the weavers and peasants. How I did enjoy it all!'

After Van Rappard's visit Vincent had no distraction other than a few acquaintances in Eindhoven, with whom he had come into contact through the

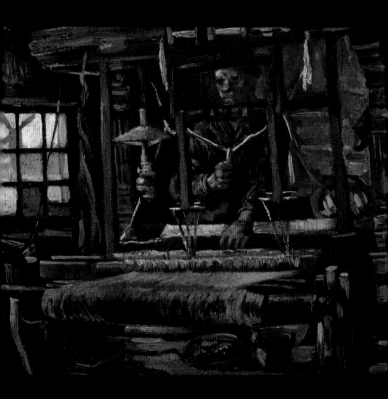

A weaver's cottage, July 1884

house painter, who furnished his colours. They were a former goldsmith, Hermans; a tanner, Kerssemakers; and also a telegraph operator whose name was not mentioned – all of whom Vincent initiated into the art of painting. Mr. Kerssemakers recorded his reminiscences of that time in the weekly *De Amsterdammer* of April 14 and 21, 1912, and included the following description of Vincent's studio, which according to him looked quite 'Bohemian'.

'One was amazed at the way all the available hanging or standing room was filled with paintings, drawings in watercolour and in crayon: heads of men and women whose clownish turned-up noses, protruding cheekbones and large ears were strongly accentuated, the rough paws calloused and furrowed; weavers and weaving looms, women spooling yarn, potato planters, women busy weeding, innumerable still lifes, certainly as many as ten studies in oils of the little old chapel at Nuenen, which he was so enthusiastic about that he had painted it in all seasons and in all weathers. (Later this little chapel was pulled down by the Nuenen vandals, as he called them). A great heap of ashes around the stove, which had never known a brush or stove polish, a small number of chairs with cane bottoms, and a cupboard with at least thirty different birds' nests, all kinds of mosses and plants

brought along from the moor, some stuffed birds, a spool, a spinning wheel, a complete set of farm tools, old caps and hats, coarse bonnets and hoods, wooden shoes, etc.'

He also spoke about their trip to Amsterdam (in the autumn of 1885) to see the Rijksmuseum, how Vincent in his rough ulster and his inseparable fur cap calmly sat painting a few small views of the city in the waiting room of the station; how they saw the Rembrandts in the museum, how Vincent could not tear himself away from the *Jewish Bride* and said at last, 'Would you believe it ... I should be happy to give ten years of my life if I could go on sitting here in front of this picture for a fortnight, with only a crust of dry bread for food?'

Dry bread was nothing unusual to him; according to Kerssemakers, Vincent never ate it any other way, in order not to 'pamper' himself too much. His impression of Vincent's work is given as follows:

'On ... my first visit to ... Nuenen it was impossible for me to get the right insight into his work; it was so totally different from what I had imagined it would be ... so rough and unkempt, so harsh and unfinished, that ... I was unable to think it good or beautiful.

'On my second visit the impression ... was considerably better, although in my ignorance I still thought

that either he could not draw or that he carelessly neglected to draw his figures, and I took the liberty of telling him so straight out. He was not at all cross at this, he only laughed and said, "Later on you will think differently."'

Meanwhile the winter days passed gloomily at the vicarage. 'For Vincent I should wish that the winter were over; he cannot work out of doors and the long evenings are not profitable for his work. We often think that it would be better for him to be among people of his own profession, but we cannot dictate to him,' wrote his father in December. Mother complained, 'How is it possible to behave so unkindly? If he has wishes for the future, let him exert himself, he is still young enough; it is almost impossible to bear it. I think he wants a change – perhaps he might find something that would give him inspiration. Here it is always the same, and he never speaks to anyone.' But still she found one bright spot: 'We saw that Vincent received a book from you. He seems to enjoy reading it very much. I heard him say, "That is a fine book," so you have given him great pleasure. I am glad that we get books regularly from the reading club; the illustrations in the magazines interest him most, and then there is the *Nouvelle Revue*, etc.; every week something new is a great pleasure to him.'

Incessantly Vincent continued his work in the gloomy cottages of peasants and weavers. 'I've hardly ever begun a year with a gloomier aspect, in a gloomier mood,' he wrote on New Year's Day 1885. 'He seems to become more and more estranged from us,' complained his father, whose letters became more and more melancholy, as if he was not equal to the difficulties of living with his gifted, unmanageable son, and felt helpless against Vincent's unbridled violence. 'This morning I talked things over with Vincent; he was in a kind mood and said there was no particular reason for his being depressed,' said the father. 'May he meet with success anyhow,' are the last words he wrote about Vincent in a letter of March 25. Two days later, coming home from a long walk across the heath, he fell down on the threshold of his home and was carried lifeless into the house. Hard times followed in the vicarage; Mother could remain there another year, but for Vincent it brought immediate changes. As a result of several unpleasant discussions with the other members of the family, he resolved to live no longer at the vicarage, but took up his abode in the studio, where he stayed from May to November. Henceforth there was not a single thing to distract him from his aim – to paint peasant life. He spent those months in the cottages of the weavers or

Still Life with Bible, novel and extinguished candle, October 1885
The bible belonged to Van Gogh's father, and is open at Isaiah 53:
'Surely he hath borne our griefs, and carried our sorrows: yet we
did esteem him stricken, smitten of God, and afflicted.'
The novel is Zola's La Joie de Vivre.

with the peasants in the field. 'It is a good thing to be deep in the snow in the winter; in autumn, deep in the yellow leaves, in summer, amid the ripe wheat; in spring, in the grass ... always with the mowers and the peasant girls, with a big sky overhead in summer, by the fireside in winter, and to feel that it has always been so and always will be' (letter 413). He was now in harmony with himself and his surroundings, and when he sent Theo his first great picture, *The Potato Eaters**, he could say in good reason that it is 'from the heart of the peasant's life.'

An uninterrupted series of studies follow; the cottages of the old peasants and their witchlike wives, the old church tower of the cemetery, the autumn landscapes and the bird's nests, a number of still lifes and the strong drawings of the Brabant peasants. In Nuenen he also wrote the beautiful passages about colour, in reference to Delacroix's laws of colours. It seems strange for him, afterward one of the first impressionists, even neo-impressionists, to declare, 'There is a school – I believe – of impressionists. But I know very little about it' (letter 402), and in his usual spirit of contradiction he later adds, 'From what you

* Van Gogh Museum, Amsterdam

Overleaf: The Potato Eaters, April-May 1885

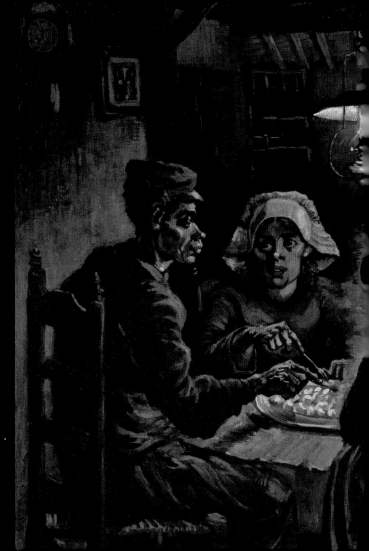

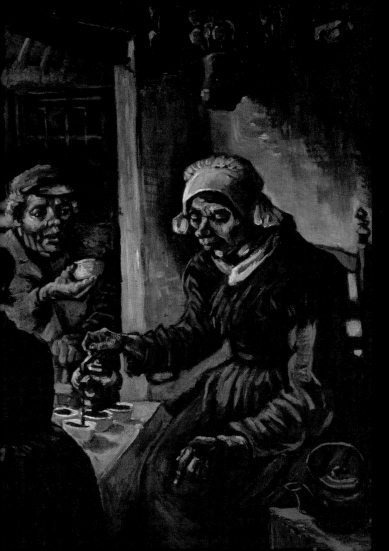

have told me about impressionism I have learned that it is different from what I thought; but as for me, I find Israëls, for instance, so enormous that I am not very curious about it or desirous of anything different or new. I think I shall change a great deal in touch and colour, but I expect to become rather darker in my colours than lighter.' A soon as he came to France, he thought differently.

During the last days of his stay in Nuenen difficulties arose between him and the Catholic priest, who had for a long time looked askance at the studio next to his church, and now forbade his parishioners to pose for Vincent. The latter was already thinking about a change. He gave notice of leaving his studio on May 1, but started for Antwerp toward the end of November, leaving all his Brabant work behind. When in May his mother also left Nuenen, everything belonging to Vincent was packed in cases, left in the care of a carpenter in Breda and – forgotten! After several years the carpenter finally sold everything to a junk dealer.

What Theo's opinion of his brother was at that time is shown in his letter to his sister on October 13, 1885, in which he wrote: 'Vincent is one of those who has gone through all the experiences of life and has retired from the world; now we must wait and see if

he has genius. I think he has ... If he succeeds in his work, he will be a great man. As to worldly success, it will perhaps be the same with him as with Heyerdahl*: appreciated by some but not understood by the public at large. Those, however, who care whether there is really something in the artist more than mere superficial brilliance will respect him; and in my opinion that will be sufficient revenge for the animosity of so many others.'

In Antwerp Vincent rented for 25 francs a month a little room over a small paint dealer's shop at 194 Rue des Images. It was only a very small room, but he made it cosy with Japanese prints on the wall. When be had rented a stove and a lamp, he felt himself safe and wrote with profound satisfaction, 'I shall not easily get bored, I assure you.' On the contrary, he spent this three months' stay in one feverish intoxication of work. The town life which he had missed so long fascinated him; he had neither eyes enough to see nor hands enough to paint: to make portraits of all the interesting types he met was his delight, and in order to pay the models, he sacrificed everything he had. He did not bother about food. '… when I receive … money my greatest appetite is not for food, though I

*Norwegian painter, then in Paris.

have fasted, but the appetite for painting is even stronger, and I at once set out to hunt for models, and continue until all the money is gone,' he wrote.

In January when he realized that he could not go on like that, the expenses being too heavy, he became a pupil at the academy, where the tuition was free and he found models every day. Hageman and De Baseleer were there among his fellow pupils, and from Holland there was Briët. In the evening he worked again in the drawing class and after that, often till late at night, at a club where they also drew from life. His health could not stand the strain, and in the beginning of February he wrote that he was literally worn out and exhausted; according to the doctor it was complete prostration. He seemed to have no thought of giving up his work, however, though he began to make plans for a change: the course at the academy was almost over and he had already had many disagreements with his teachers, for he was much too independent and self-willed to submit to their guidance. Something had to be done. Theo thought it best for Vincent to go back to Brabant, but he himself wanted to go to Paris. Theo asked him to put off the visit at least till June, when he would have rented a

Opposite: Head of a skeleton with burning cigarette, c. 1885-6

larger apartment; but with his usual impetuosity Vincent could not wait so long, and one morning toward the end of February Theo received in his office at the Boulevard a little note written in pencil: Vincent had arrived and awaited him in the Salon Carré of the Louvre. Probably he left all his work in Antwerp – perhaps his landlord the paint dealer kept it for the unpaid rent of the room. Certainly none of the studies which he wrote about – the view of the park, of the Cathedral, Het Steen [The Castle], etc. – has ever been found again.

After the meeting in the Louvre Vincent moved into Theo's apartment on the Rue de Laval. As there was no room for a studio, he worked during the first month at Cormon's studio, which did not satisfy him at all. When they moved in June to 54 Rue Lepic in Montmartre, he had a studio of his own and never went back to Cormon.

The new apartment on the third floor had three rather large rooms, a small room and a kitchen. The living room was comfortable and cosy with Theo's beautiful old cabinet, a sofa and a big stove, for both the brothers were very sensitive to the cold. Next to that was Theo's bedroom. Vincent slept in the small

Opposite: View from Theo's room, March-April 1887

View of Paris,
June-July 1886

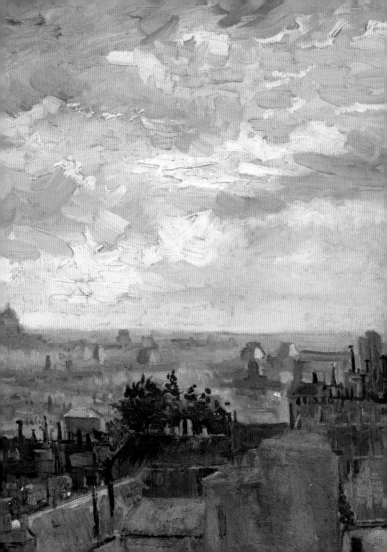

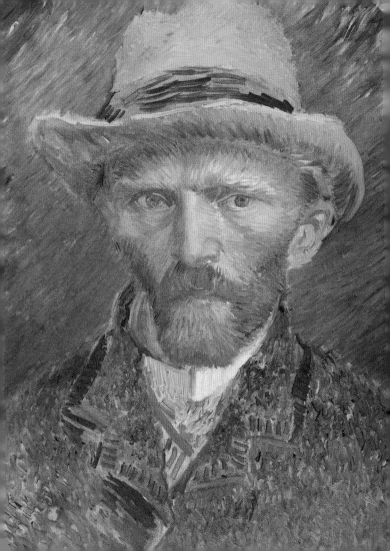

room and behind that was the studio, an ordinary-sized room with one not very large window. Here he first painted his immediate surroundings – the view from the studio window, the Moulin de la Galette viewed from every side, the window of Madame Bataille's small restaurant where he had his meals, little landscapes of Montmartre, which was at that time still quite countrified – all painted in a soft, tender tone like that of Mauve. Later he painted flowers and still life and tried to renew his palette under the influence of the French plein air painters such as Monet, Sisley, Pissarro, etc., for whom Theo had long since opened the way to the public.

The change of surroundings and the easier and more comfortable life, without any material cares, at first greatly improved Vincent's health. In the summer of 1886 Theo wrote to his mother, 'We like the new apartment very much; you would not recognize Vincent, he has changed so much, and it strikes other people more than it does me. He has undergone a major operation in his mouth, for he had lost almost all his teeth through the bad condition of his stomach. The doctor says that he has now quite recovered his health; he makes great progress in his work and

Opposite: Self-portrait in grey felt hat, 1886-7

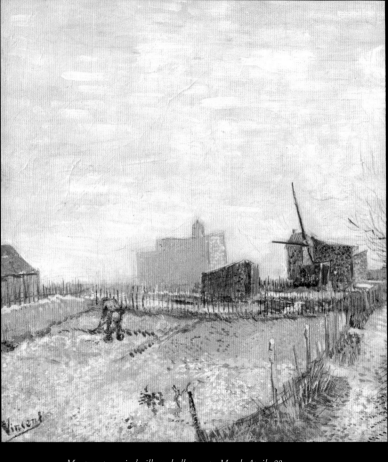

Montmartre: windmills and allotments, March-April 1887

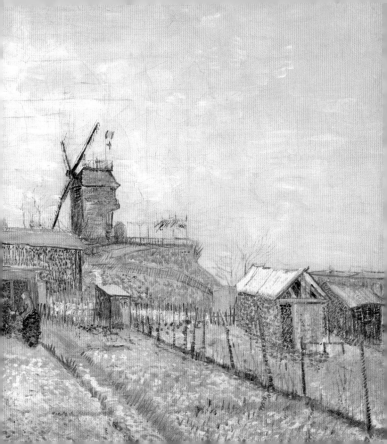

has begun to have some success. He is in much better spirits than before and many people here like him ... he has friends who send him every week a lot of beautiful flowers which he uses for still life. He paints chiefly flowers, especially to make the colours of his next pictures brighter and clearer. If we can continue to live together like this, I think the most difficult period is past, and he will find his way.'

To continue living together, that was the great difficulty; of all that Theo did for his brother, there was perhaps nothing that entailed a greater sacrifice than his having endured living with him for two years. For when the first excitement of all the new attractions in Paris had passed, Vincent soon fell back into his old irritability; perhaps the city life did not agree with him either and overstrained his nerves. Whatever might be the cause, his temper during that winter was worse than ever, and made life very hard for Theo, whose own health was not of the best at that time. Circumstances put too heavy a strain on him, his own work was very strenuous and exhausting, he had made the gallery on the Boulevard Montmartre a center of the impressionists; there were Monet, Sisley, Pissarro and Raffaelli, Degas – who exhibited nowhere

Opposite: Still life with gladioli and Chinese asters, 1886

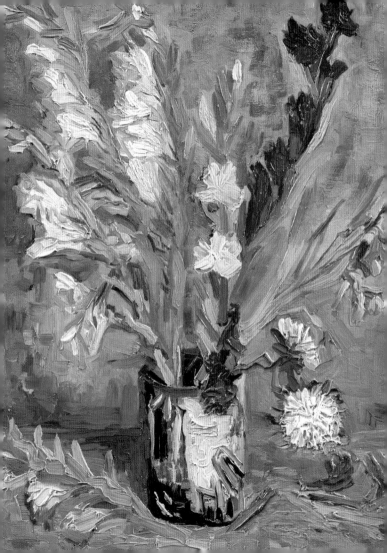

else – Seurat, etc. But to introduce that work to the public, which filled the small entresol every afternoon from five until seven, what discussions, what endless debates, had to be held. On the other hand, how he had to defend the rights of the young painters against *ces messieurs*, as Vincent always called the heads of the firm. When he came home tired out in the evening, he found no rest; the impetuous, violent Vincent would begin to expound his own theories about art and art dealing, which always concluded that Theo ought to leave Goupil and open a gallery for himself. This lasted till far into the night; indeed, sometimes he sat down on a chair beside Theo's bed to spin out his last arguments. 'Do you feel how hard it sometimes is to have no other conversation than with gentlemen who speak of business matters and with artists whose life generally is difficult enough – but never to come into contact with women and children of your own sphere? You can have no idea of the loneliness in a big city,' Theo once wrote to his youngest sister, and to her he sometimes opened his heart about Vincent. 'My home life is almost unbearable. No one wants to come and see me any more because it always ends in quarrels, and besides, he is so untidy that the room looks far from attractive. I wish he would go and live by himself. He sometimes mentions it, but if I were to

tell him to go away, it would just give him a reason to stay; and it seems I do him no good. I ask only one thing of him, to do me no harm; yet by his staying he does so, for I can hardly bear it.' 'It seems as if he were two persons one, marvellously gifted, tender and refined, the other, egoistic and hard-hearted. They present themselves in turns, so that one hears him talk first in one way, then in the other, and always with arguments on both sides. It is a pity that he is his own enemy, for he makes life hard not only for others but also for himself.' But when his sister advised him to 'leave Vincent for God's sake," Theo answered, 'It is such a peculiar case. If only he had an other profession, I would long ago have done what you advise me. I have often asked myself if I have not been wrong in helping him continually, and have often been on the point of leaving him to his own devices. After receiving your letter I have thought it over again, but I think in this case I must continue in the same way. He is certainly an artist, and if what he makes now is not always beautiful, it will certainly be of use to him later; then his work will perhaps be sublime, and it would be a shame to have kept him from his regular study. However unpractical he may be, if he succeeds in his work there will certainly come a day when he will begin to sell his pictures …

'I am firmly resolved to continue in the same way as till now, but I do hope that he will change his lodgings in some way or other.'

However, that separation did not take place. The old love and friendship which had bound them together since childhood did not fail them, even now. Theo managed to restrain himself, and in the spring he wrote, 'As I feel much stronger than last winter, I hope to be able to bring a change for the better in our relations; there will be no other change for the present, and I am glad of it. We are already most of us so far from home that it's no use causing still more separation.' Full of courage, he continued to help Vincent bear the burden of his life.

With spring everything improved. Vincent could work in the open air again and painted much at Asnières, where he painted the beautiful triptych of *L'Isle de la Grande Jatte*,* the borders of the Seine with their gay, bright restaurants, the little boats on the river, the parks and gardens, all sparkling with light and colour. At that time he saw much of Émile Bernard, a young painter fifteen years younger than himself, whom he had met at Cormon's. He had a

* *The Seine*, private collection, Japan; *The Avenue in Voyer-d'Argenson Park at Asnières*, private collection, Taiwan; *Entrance of Voyer-d'Argenson Park at Asnières*, The Israel Museum, Jerusalem

Entrance of Voyer d'Argenson Park at Asnières, 1887
One of the L'Isle de la Grand Jatte triptych

little wooden studio in his parents' garden at Asnières where they sometimes worked together and where Vincent began a portrait of Bernard. But one day he had a violent quarrel with old Mr. Bernard about the latter's projects for his son. Vincent could bear no contradiction; he ran away in a passion with the still-wet portrait under his arm, and he never set foot again in the Bernards' house. But the friendship with young Bernard continued, and his *Letters of Vincent van Gogh* (published in 1901 by Vollard in Paris) contain the most beautiful pages ever written about Vincent.

In the winter of 1887-88, Vincent again painted portraits – the famous self-portrait before the easel,* and many other self-portraits, as well as Père Tanguy, the old merchant of colours in the Rue Clauzel who allowed his customers to exhibit their pictures in his show window.† He has occasionally been described as a Mæcenas; but the poor old man completely lacked the necessary qualities, and even if he had possessed them, his shrewd wife would not have allowed him to

* Van Gogh Museum, Amsterdam †Van Gogh painted three portraits of Père Tanguy: the first, more conventional, is in the Ny Carlsberg Glyptotek, Copenhagen; the second, illustrated opposite, was kept by Tanguy and is now in a private collection, Greece; the third is in the Musée Rodin, Paris

Opposite: Portrait of Père Tanguy, 1888

Still-life in yellow (Quinces, lemons, pears and grapes), 1887

use them. He sent, and justly too, very meticulous bills for the colours he furnished and did not understand very much about the pictures on view in his window.

The famous picture *Interior with Lady by a Cradle** was created during that time. When Theo, who had that winter bought a few pictures from young artists to help them, wanted to do the same for Vincent, the latter painted for him the beautiful *Still Life in Yellow,†* sparkling and radiant as from an inner glow, and in red letters he dedicated it 'To my brother Theo.'

Toward the end of the winter he became tired of Paris; city life was too much for him, the climate too grey and chilly. In February 1888 he travelled south. 'After all these years of care and misfortune his health has not grown any stronger, and he decidedly wanted to be in a milder climate,' Theo wrote. 'He has first gone to Arles to look about him, and then will probably go to Marseilles.

'Before he went away I went a few times with him to hear a Wagner concert; we both enjoyed it very much. It still seems strange that he is gone. He has meant so much to me of late.' And Bernard tells how

* *Mother by a Cradle, Portrait of Leonie Rose Davy-Charbuy*, 1887, Van Gogh Museum † *Still life in yellow (Quinces, lemons, pears and grapes)*, 1887, Van Gogh Museum

busy Vincent was that last day in Paris arranging the studio, 'so that my brother will think me still here.'

At Arles, Vincent reached his peak. After the oppressiveness of Parisian life he, with his innate love of nature, revived in sunny Provence. There followed a happy time of undisturbed and immense productivity. Without paying much attention to the town of Arles itself, with its famous remains of Roman architecture, he painted the landscape, the glorious wealth of spring blossoms in a series of orchards in bloom, the wheatfields under the burning sun at harvest time, the almost intoxicating richness of the autumn colours, the glorious beauty of the gardens and parks, *The Poet's Garden,** where he saw as in a vision the ghosts of Dante and Petrarch. He painted *The Sower,*† *The Sunflowers,*¶ *The Starry Night,*§ the sea at Sts-Maries: his creative impulse and power were inexhaustible. 'I have a terrible lucidity at moments, these days when nature is so beautiful, I am not conscious

*Art Institute, Chicago †Kröller-Müller Museum, Otterlo ¶ Four primary versions: Private collection; destroyed; Neue Pinakothek, Munich; National Gallery, London. Three *répétitions*: Philadelphia Museum of Art (illustrated p. 136); Van Gogh Museum; Sompo Japan Museum of Art, Tokyo § *Starry night over the Rhone*, Musée d'Orsay

Opposite: Flowering peach tree, 1888

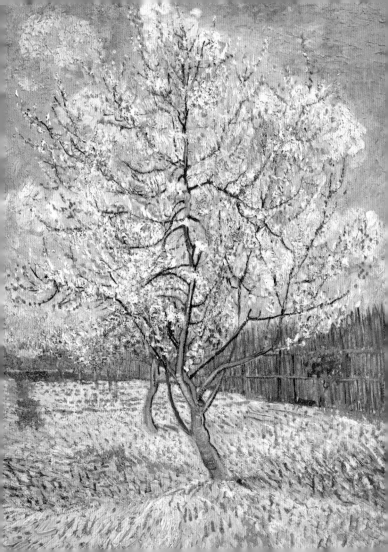

*Starry Night over
the Rhone, 1888*

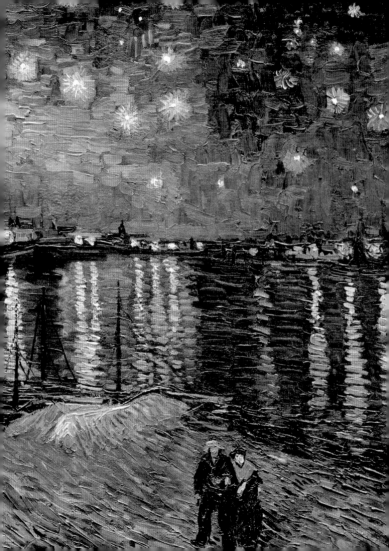

of myself any more, and the picture comes to me as in a dream.' And he exclaimed rapturously, 'Life is almost enchanted after all.'

Thereafter his letters, written in French, completely reflected what was going on inside him. Sometimes when he had written in the morning, he sat down again in the evening to tell his brother how splendid the day had been. 'I have never had such a chance, nature being so here extraordinarily beautiful.' And a day later, 'I know ... that I have already written you once today, but it has been such a lovely day again. My great regret is that you cannot see what I am seeing here.'

Completely absorbed in his work as he was, the great loneliness that surrounded him in Arles was no burden. Except for a short acquaintance with McKnight, Boch and the Zouave lieutenant Milliet, he had no friends whatever. But after he had rented a little house of his own on the Place Lamartine and arranged it after his own taste – decorating it with his pictures, and making it a *maison d'artiste* – he again felt the old longing which he had already expressed at the start of his painting career in 1880: to associate with another artist and live and work together. Just then he

Opposite: Eugène Boch, 1888

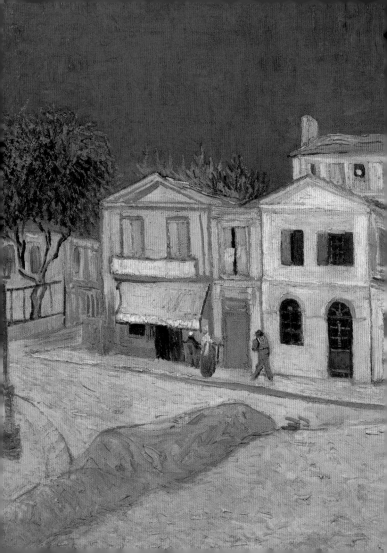

The Yellow Hou
('The Street'),
September 1888

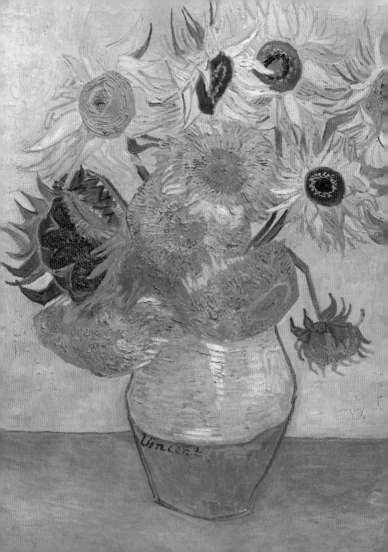

received a letter from Paul Gauguin in Brittany; he was in the greatest pecuniary embarrassment and was trying in this roundabout way to ask Theo to sell some of his pictures for him: 'I wanted to write to your brother but I am afraid to bother him because he's so busy from morning until night. The little I have sold is just enough to pay some urgent debts and in a month I shall have absolutely nothing left. Zero is a negative force ... I do not want to importune your brother, but a little word from you on this subject would set my mind at ease or at least help me to have patience. My God, how terrible are these money questions for an artist.'

At once Vincent grasped at the idea of helping Gauguin. He had to come to Arles, and they would live and work together. Theo would pay the expenses and Gauguin would give him pictures in exchange. Again and again he insisted on this plan with his innate perseverance and stubbornness, though Gauguin did not at first seem at all inclined to it. They had met in Paris, but it had been no more than a superficial acquaintance, and they were too different in talent and character ever to harmonize in daily intercourse.

Opposite: Vase with twelve sunflowers, 1889

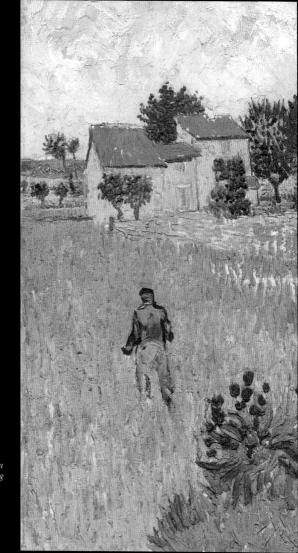

Farmhouse in Provence, 1888

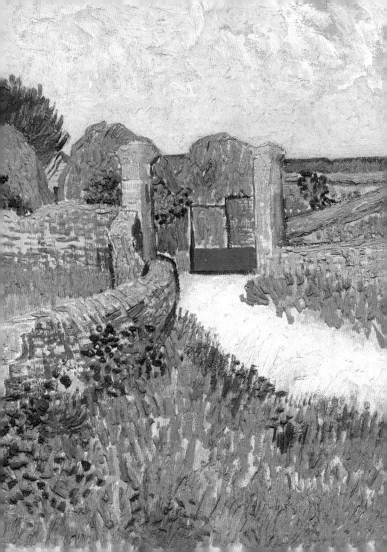

Gauguin, born in Paris in 1848, was the son of a Breton father, a journalist in Paris, and a Creole mother. His youth was full of adventures; he had gone to sea as a cabin boy, had worked in a banker's office and had painted only in his leisure hours. Then, after he had married and had a family, he devoted himself wholly to his art. His wife and children returned to her native city, Copenhagen, as he was not able to provide for them. He himself made a journey to Martinique, where he painted, among others, his famous picture, *The Negresses*. He was now in Pont Aven in Brittany, without any source of income; the great need of money made him accept Vincent's proposition and come to Arles. The whole undertaking was a sad failure and ended fatally for Vincent.

Notwithstanding the months of superhuman exertion which lay behind him, he strained every nerve in a last manifestation of power before Gauguin's arrival. 'I am vain enough to want to make a certain impression on Gauguin with my work ... I have ... pushed what I was working on as far as I could in my great desire to show him something new, and not to be subjected to his influence ... before I can show him indubitably my own originality,' wrote Vincent in letter 556. When we realize that to this last work belongs one of Vincent's most famous pictures, *La*

chambre à coucher,* and the series *The Poet's Garden*, we are rather sceptical about Gauguin's later assertion that before his arrival Vincent had merely been bungling along, and that he made progress only after Gauguin's lessons. It gives us some perspective on Gauguin's whole description of the episode at Arles, which is such a mixture of truth and fiction.†

The fact is that Vincent was completely exhausted and overstrained, and was no match for the iron Gauguin with his strong nerves and cool arguing. It became a silent struggle between them, and the endless discussions held while they sat smoking in the little yellow house were not calculated to calm Vincent. 'Your brother is indeed a little agitated, and I hope to calm him by and by,' Gauguin wrote to Theo shortly after his arrival at Arles. And to Bernard he related more frankly how little sympathy there really was between Vincent and himself. 'Vincent and I generally agree very little, especially about painting. He admires Daudet, Daubigny, Ziem, and the great Rousseau – all people whom I cannot bear. And on the contrary he detests Ingres, Raphael, Degas – all people whom I admire. I answer, "Brigadier, you are

*Three versions: Van Gogh Museum; Art Institute of Chicago (illustrated overleaf); Musee d'Orsay, Paris †*Paul Gauguin* by Charles Morice, Mercure de France, 1903

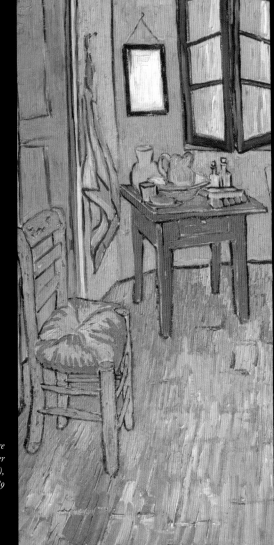

*La Chambre
à Coucher
('The Bedroom'),
September 1889*

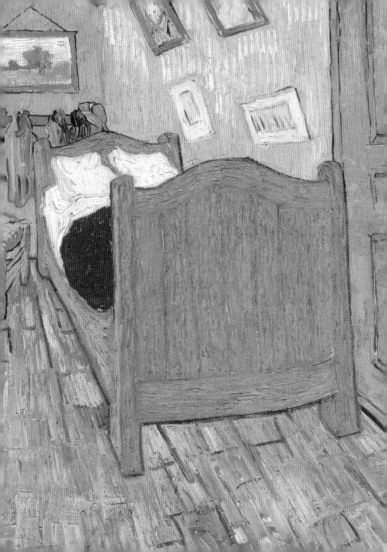

right," in order to have peace. He loves my pictures very much, but when I make them he always finds I am wrong in this or that. He is romantic, and I am rather inclined to the primitive state.' In later years when Gauguin again remembered this period, he wrote, 'Between the two of us, he like a Vulcan, and I boiling too, a kind of struggle was preparing itself…'

The situation became more and more strained. In the latter half of December Theo received from Gauguin the following letter: 'Dear Mr. van Gogh, I would he greatly obliged to you for sending me part of the money for the pictures sold.

'After all, I must go back to Paris. Vincent and I simply cannot live together in peace because of incompatibility of temper, and we both need quiet for our work. He is a man of remarkable intelligence; I respect him highly, and regret leaving; but I repeat, it is necessary. I appreciate all the delicacy in your conduct toward me and I beg you to excuse my decision.' Vincent also wrote, in letter 565, that Gauguin seemed to be tired of Arles, of the yellow house, and of himself. But the quarrel was made up; Gauguin asked Theo to consider his return to Paris as an imaginary thing, and the letter he had written as a bad dream. But it was only the calm before the storm.

Opposite: Gauguin's chair, 1888

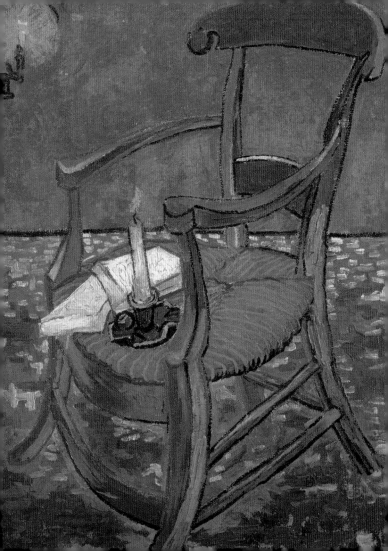

The day before Christmas – Theo and I had just become engaged and intended to go to Holland together (I was staying in Paris with my brother, A. Bonger, a friend of Theo's and Vincent's) – a telegram arrived from Gauguin which called Theo to Arles. On the evening of December 24 Vincent had in a state of violent excitement, *un accès de fièvre chaude* (an attack of high fever), cut off a piece of his ear and brought it as a gift to a woman in a brothel. A big tumult had ensued. Roulin the postman had seen Vincent home; the police had intervened, had found Vincent bleeding and unconscious in bed, and sent him to the hospital. There Theo found him in a severe crisis, and stayed with him during the Christmas days. The doctor considered his condition very serious.

'There were moments while I was with him when he was well; but very soon after he fell back into his worries about philosophy and theology. It was painfully sad to witness, for at times all his suffering overwhelmed him and he tried to weep but he could not; poor fighter and poor, poor sufferer; for the moment nobody can do anything to relieve his sorrow, and yet he feels deeply and strongly. If he might have found somebody to whom he could have

Opposite: Self-portrait with bandaged ear, 1888-9

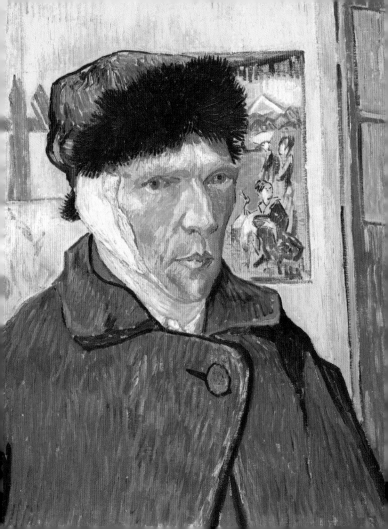

Café de la Gare, Arles
1888

disclosed his heart, it would perhaps never have gone thus far,' Theo wrote to me after he had come back to Paris with Gauguin. And a day later, 'There is little hope, but during his life he has done more than many others, and he has suffered and struggled more than most people could have done. If it must be that he dies, so be it, but my heart breaks when I think of it.'

The anxiety lasted a few more days. Dr. Rey, the house doctor at the hospital, to whose care Theo had so urgently entrusted Vincent, kept him constantly informed. 'I shall always be glad to send you tidings, for I too have a brother, I too have been separated from my family,' he wrote December 29 when the news was still very bad. The Protestant clergyman, the Reverend Mr. Salles, also visited Vincent and wrote to Theo about his condition. Then, last but not least, there was the postman, Roulin, who was quite dismayed at the accident that had befallen his friend Vincent, with whom he had spent so many pleasant hours at Joseph Ginoux's Café de la Gare, and who had painted such beautiful portraits of him and his whole family! Every day he went to the hospital for news and conveyed it faithfully to Paris; as he was not a good penman, his two sons, Armand and Camille, took turns serving as his secretary. His wife, too, who

posed for *La Berceuse** (Mme. Ginoux was the original of the *Arlésienne*†), visited her sick friend, and the first sign of recovery was Vincent's asking her about little Marcelle, the handsome baby he had painted such a short time before.

Then his condition suddenly changed for the better. The Reverend Mr. Salles wrote on December 31 that he had found Vincent perfectly calm, and that he was longing to start work again. A day later Vincent himself wrote a short note in pencil to reassure Theo, and on January 2 another note came from him, to which Dr. Rey added a word of reassurance. On January 3 an enthusiastic letter from Roulin: 'Vincent has quite recovered. He is better than before that unfortunate accident happened to him.' He, Roulin, would go to the doctor and tell him to allow Vincent to go back to his pictures. The following day they had been out and spent four hours together. 'I am very sorry my first letters were so alarming, and I beg your pardon; I am glad to say I have been mistaken in this case. He only regrets all the trouble he has given you, and he is sorry for the anxiety he has caused. You may

*Five versions: Kröller-Müller Museum, Otterlo; Museum of Fine Arts, Boston; Stedelijk Museum, Amsterdam; Metropolitan Museum of Art, New York; Art Institute of Chicago †Two versions: Musée d'Orsay, Paris; Metropolitan Museum of Art, New York

Opposite: Mme. Roulin and Marcelle, 1888

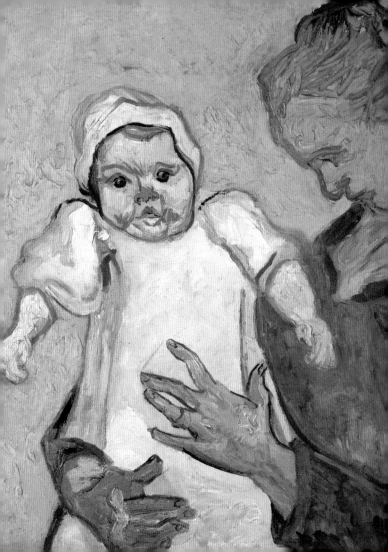

rest assured that I will do all I can to give him some distraction,' wrote Roulin.

On January 7 Vincent left the hospital, apparently entirely recovered; but, alas, any great excitement or fatigue caused the nervous attacks to return ... They lasted a varying length of time, but also left him periods of almost perfect health, during which he went back to work with the old vigour. In February he was taken back to the hospital for a short time. After his return to his little house the neighbours, who had grown afraid of him, petitioned the mayor, complaining that it was dangerous to leave him at liberty. Consequently he was actually sent to the hospital again on February 27 – this time without any cause. Vincent himself kept the deepest silence about this unhappy affair for a whole month, but the Reverend Mr. Salles sent Theo a faithful report. On March 2 he wrote, 'The neighbours have raised a fuss over nothing. The acts with which they have reproached your brother (even if they were exact) do not justify charging a man with insanity or depriving him of his liberty. Unfortunately, the foolish act which necessitated his original removal to the hospital made people misunderstand anything singular which the poor young man does; from anyone else it would remain

Opposite: Joseph Roulin, April 1889

unobserved, from him, everything at once assumes a particular importance ... As I told you yesterday, at the hospital he has won everybody's favour; after all, the doctor – not the chief of police – is the judge in these matters.'

The whole affair made a deep impression on Vincent and caused another attack, from which he recovered with astonishing rapidity. Again, it was the Reverend Mr. Salles who told Theo of Vincent's recovery. On March 18 he wrote, 'Your brother has spoken to me with perfect calmness and lucidity about his condition and also about the petition signed by his neighbours. The petition grieves him very much. "If the police," he says, "had protected my liberty by preventing the children and even the grown-ups from crowding around my house and climbing the windows as they have done (as if I were a curious animal), I should have more easily retained my self-possession; in any event I have done no harm to any-one." In short, I found your brother transformed; God grant that this favourable change he maintained. His condition has an indescribable quality: it is impossible to understand the sudden and complete changes which have taken place in him. It is evident that as long as he is in the condition in which I found him, there can be no question of interning him in an

asylum; nobody, so far as I know, would have this sinister courage.' A day after this interview with the Reverend Mr. Salles, Vincent wrote again to Theo and justly complained that such repeated emotions might cause a passing nervous attack to change into a chronic evil. And with quiet resignation, he added, '... to suffer without complaint is the one lesson that has to be learned in this life.'

He soon recovered his liberty, but continued to live in the hospital until the Reverend Mr. Salles could find him new lodgings in a different part of town. His health was so good that the Reverend Mr. Salles wrote on April 19, 'Sometimes not even a trace seems left of the disease which has affected him so grievously.'

But when he was going to settle with the new landlord, he suddenly avowed to the Reverend Mr. Salles that he lacked the courage to start a new studio again, and that he himself thought it best to go to an asylum for a few months. 'He is fully conscious of his condition, and speaks with me about his illness, which he fears will come back, with a touching candour and simplicity,' wrote the Reverend Mr. Salles. "I am not fit," he told me the day before yesterday, "to govern myself and my affairs. I feel quite different than I was before." The Reverend Mr. Salles then looked around and advised the asylum of St Rémy, situated quite

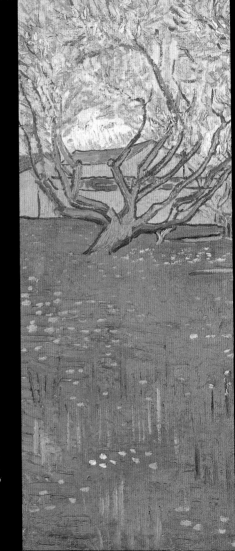

Orchards in blossom,
view of Arles,
April 1889

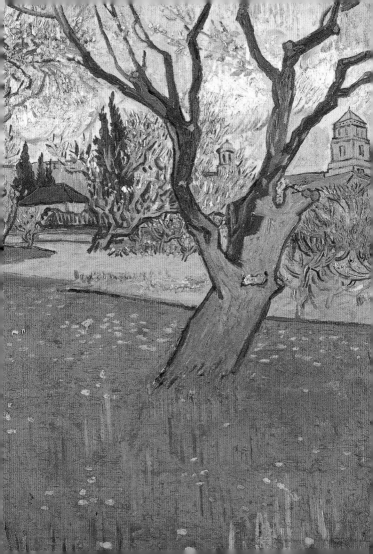

near Arles; he added that the doctors at Arles approve of it, 'given the state of isolation in which your brother would find himself upon leaving the hospital.'

It was that which troubled Theo most. Shortly before our marriage, in answer to my question whether Vincent would not rather return to Paris or spend some time with his mother and sisters in Holland, as he was so alone in Arles, Theo wrote me, 'Yes, one of the greatest difficulties is that, whether in good or bad health, his life is so utterly cut off from the outer world. But if you knew him, you would be doubly aware of how difficult it is to solve the question of what must and can be done for him.

'As you know, he has long since broken with what is called convention. His way of dressing and his manners show directly that he is an unusual personality, and people who see him say, "He is mad." To me it does not matter, but for Mother that is impossible. Then there is something in his way of speaking that makes people either like or dislike him strongly. He always has people around him who sympathize with him, but also many enemies. It is impossible for him to associate with people in an indifferent way; it is either one thing or the other. It is difficult even for those who are his best friends to remain on good terms with him, as he spares nobody's feelings. If I

had time, I would go to him and, for instance, go on a walking tour with him. That is the only thing, I imagine, that would do him good. If I can find some-body among the painters who would like to do it, I will send him. But those with whom he would like to go are somewhat afraid of him, a circumstance which Gauguin's visit did nothing to change.

'Then there is another thing which makes me afraid to have him come here. In Paris he saw so many things which he liked to paint, but again and again it was made impossible for him to do so. Models would not pose for him and he was forbidden to paint in the streets; with his irascible temper this caused many unpleasant scenes which excited him so much that he became completely unapproachable and at last he developed a great aversion for Paris. If him-self wanted to come back here, I would not hesitate for a moment ... but again I think I can do no better than to let him follow his own inclinations. A quiet life is impossible for him, except alone with nature or with very simple people like the Roulins; for wherev-er he goes he leaves the trace of his passing. Whatever he sees that is wrong he must criticize, and that often occasions strife.

'I hope that he will find, sometime, a wife who loves him so much that she will share his life; but it

will not be easy. Do you remember that girl in *Virgin Soil* by Tourgenev, who was with the nihilists and brought the compromising papers across the frontiers? I imagine she might be like that – somebody who has gone through life's misery to the bottom...It pains me not to be able to do anything for him, but for uncommon people, uncommon remedies are necessary, and I hope these will be found where ordinary people would not look for them.'

Vincent himself now decided to go to St Rémy.

Theo's first impression of Vincent's resolution was that it might be a kind of self-sacrifice to avoid being in anybody's way, and he wrote him once more, asking with emphasis whether he would not rather go to Pont-Aven or come to Paris.

But as Vincent stuck to his decision, Theo wrote him: 'I do not consider your going to St Rémy a retreat, as you call it, but simply a temporary rest cure which will help you come back with renewed strength. For my part I attribute your illness principally to neglect of your material existence. In an establishment like that of St Rémy there is a great regularity in the hours for meals, etc., and I think that such regularity will do you no harm – quite the contrary.'

When Theo had arranged everything with the

Opposite: Hospital at Saint-Rémy, 1889

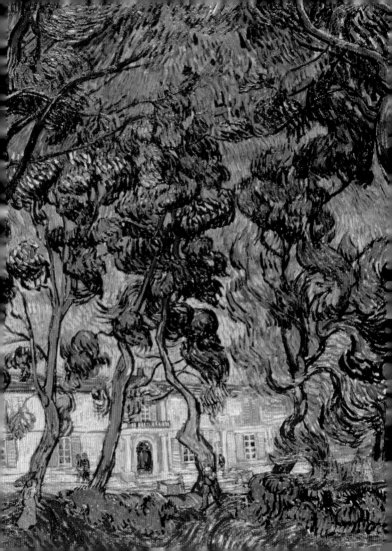

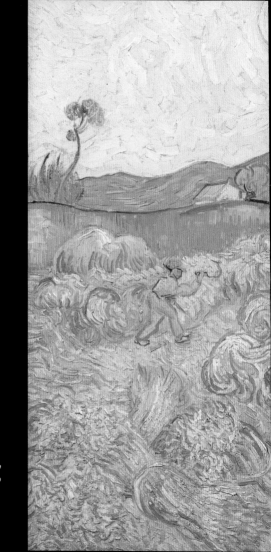

Wheatfield with reaper, 1889

director of the establishment, Dr. Peyron, including a free room for Vincent and a room where he could paint and as much liberty as possible to wander about as he liked, Vincent left for St Rémy on May 8, accompanied by the Reverend Mr. Salles, who wrote Theo the next day: 'Our journey to St Rémy has been accomplished under the most excellent conditions. Monsieur Vincent was perfectly calm and explained his case himself to the director as a man fully conscious of his condition. He remained with me till my departure, and when I took leave of him he thanked me warmly and seemed somewhat moved, thinking of the new life he was going to lead in that house. Monsieur Peyron has assured me that he will show him all the kindness and consideration which his condition demands.'

How touching sounds that 'somewhat moved' at the departure of the faithful companion! His leave-taking broke the last tie that united Vincent with the outer world; he stayed behind in what was worse than the greatest loneliness, surrounded by neurotics and lunatics, with nobody to whom he could talk, nobody who understood him. Dr. Peyron was kindly disposed, but he was reserved and silent; the monthly letters by which he kept Theo informed of the situation lacked the warm sympathy of the doctors in the hospital at Arles.

Vincent spent a full year in these cheerless surroundings, struggling with unbroken energy against the ever-returning attacks of his illness but continuing his work with the old restless zeal which alone could keep him living now that everything else had failed him. He painted the desolate landscape which he saw from his window at sunrise and sunset; he wandered far to paint the wide fields, bordered by the foothills of the Alps; he painted the olive orchards with their dismally twisted branches, the gloomy cypresses, the somber garden of the asylum; and he also painted the *Reaper* – 'an image of death as the great book of nature speaks of it.'*

It was no longer the buoyant, sunny, triumphant work of Arles. There sounded a deeper, sadder tone than the piercing clarion of his symphonies in yellow during the previous year: his palette had become more sober, the harmonies of his pictures had passed into a minor key.

'To suffer without complaint' – well had he learned that lesson. When the treacherous evil attacked him again in August, just when he had hoped to be cured for good, he only uttered a despondent, 'I no longer see any possibility of having courage or hope ...'

*Private collection

Olive Trees
September 1889

He struggled painfully through the winter, during which, however, he painted some of his most beautiful works: the *Pietà* and the *Good Samaritan* after Delacroix;* the *Resurrection of Lazarus* after Rembrandt;† the *Four Hours of The Day* after Millet.¶ A few months followed during which he was unable to work, but now he felt that he would lose his energy forever if he stayed in those fatal surroundings any longer; he must get away from St Rémy.

For some time Theo had been looking around for a suitable place – near Paris and yet in the country – where Vincent could live under the care of a physician who would at the same time be a friend to him. On Pissarro's recommendation he finally found this at Auvers-sur-Oise, an hour by train from Paris; Dr. Gachet, who in his youth had been a friend of Cézanne, Pissarro and the other impressionists, lived there.

Vincent returned from the South on May 17, 1890. First he was going to spend a few days with us in Paris. A telegram from Tarascon informed us that he was going to travel that night and would arrive at ten in the morning. That night Theo could not sleep for

*Two versions: Vatican Museums; Van Gogh Museum. †Kröller-Müller Museum, Otterlo; Van Gogh Museum. ¶ *Morning*: Hermitage, St Petersburg; *Noon*: Musée d'Orsay, Paris; *Evening*: Menard Art Museum, Komaki; *Night*: Van Gogh Museum

anxiety lest something happen to Vincent on the way; he had only just recovered from a long and serious attack, and had refused to be accompanied by anyone. How thankful we were when it was at last time for Theo to go to the station!

From the Cité Pigalle to the Gare de Lyon was a long distance; it seemed an eternity before they came back. I was beginning to be afraid that something had happened when at last I saw an open fiacre enter the Cité; two merry faces nodded to me, two hands waved – a moment later Vincent stood before me.

I had expected a sick man, but here was a sturdy, broad-shouldered man, with a healthy colour, a smile on his face, and a very resolute appearance; of all the self-portraits, the one before the easel is most like him at that period. Apparently there had again come the sudden puzzling change in his condition that the Reverend Mr. Salles had already observed to his great surprise at Arles.

'He seems perfectly well; he looks much stronger than Theo,' was my first thought.

Then Theo drew him into the room where our little boy's cradle was; he had been named after Vincent. Silently the two brothers looked at the quietly sleeping baby – both had tears in their eyes. Then Vincent turned smilingly to me and said, pointing to

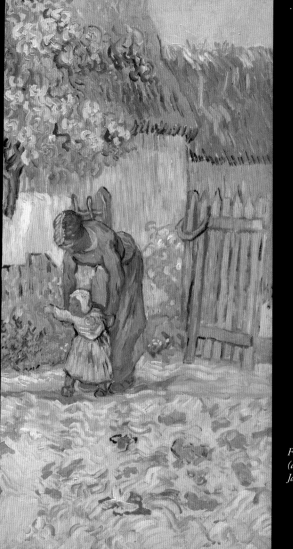

*First Steps
(after Millet),
January 1890*

the simple crocheted cover on the cradle, 'Do not cover him too much with lace, little sister.'

He stayed with us three days, and was cheerful and lively all the time. St Rémy was not mentioned. He went out by himself to buy olives, which he used to eat every day and which he insisted on our eating too. The first morning he was up very early and was standing in his shirt sleeves looking at his pictures, of which our apartment was full. The walls were covered with them – in the bedroom, the *Orchards in Bloom*;* in the dining room over the mantelpiece, the *Potato Eaters*; in the sitting room (salon was too solemn a name for that cosy little room), the great *Landscape from Arles*† and the *Night View on the Rhone*. Besides, to the great despair of our *femme de ménage*, there were under the bed, under the sofa, under the cupboards in the little spare room, huge piles of unframed canvases; they were now spread out on the ground and studied with great attention.

We also had many visitors, but Vincent soon perceived that the bustle of Paris did him no good, and he longed to set to work again. So he started on May 21

Pink Orchard; Peach tree in Blossom; White Orchard, all Van Gogh Museum, Amsterdam; †Van Gogh Museum (see drawing pp. 2-3)

Opposite: Roses, 1890

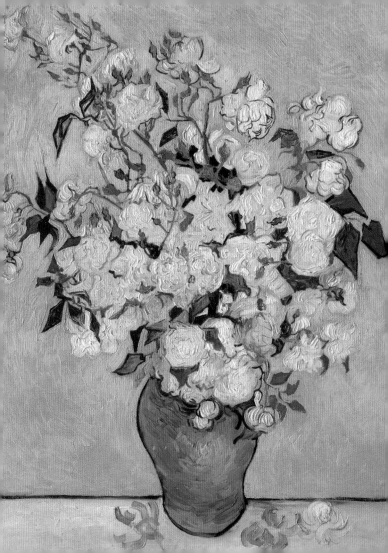

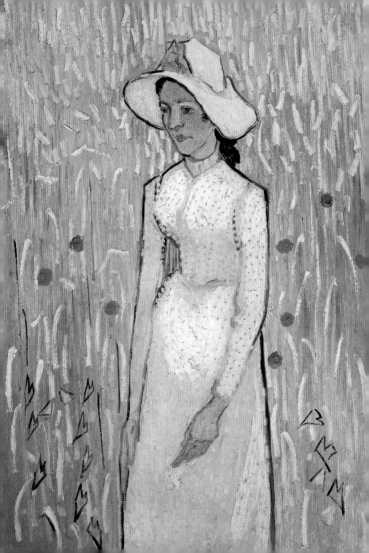

for Auvers, with an introduction to Dr. Gachet, whose faithful friendship was to become his greatest support during the short time he spent at Auvers. We promised to come and see him soon, and he also wanted to come back to us in a few weeks to paint our portraits. In Auvers he lodged at an inn and went to work immediately.

The hilly landscape with the sloping fields and thatched roofs of the village pleased him, but what he enjoyed most was having models and again painting figures. One of the first portraits he painted was of Dr. Gachet,* who immediately felt great sympathy for Vincent. They spent most of their time together and became great friends – a friendship not ended by death, for Dr. Gachet and his children continued to honour Vincent's memory with rare piety, which became a form of worship, touching in its simplicity and sincerity.

'The more I think of it, the more I think Vincent was a giant. Not a day passes that I do not look at his pictures. I always find there a new idea, something different each day ... I think again of the painter and

*Two versions: private collection; Musée d'Orsay (illustrated overleaf); and an etching

Opposite: Girl in White, 1890

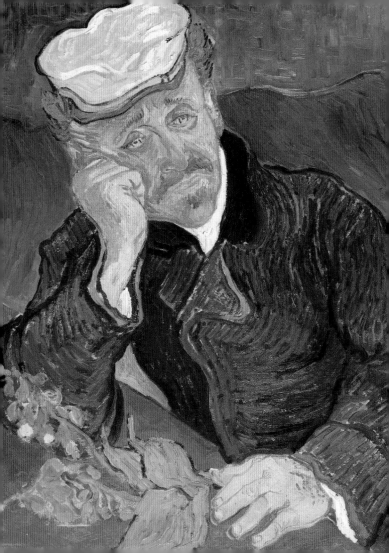

I find him a colossus. Besides, he was a philosopher ...'
Gachet wrote to Theo shortly after Vincent's death.
Speaking of the latter's love for art, he said, 'Love of
art is not exact; one must call it faith – a faith that
maketh martyrs!' None of his contemporaries had
understood him better.

It was curious to note that Dr. Gachet himself
somewhat resembled Vincent physically (he was
much older), and his son Paul – then a boy of fifteen
years – looked somewhat like Theo.

The Gachet house, built on a hill, was full of pic-
tures and antiques, which received but scanty daylight
through the small windows; in front of the house
there was a splendid terraced flower garden, at the
back a large yard where all kinds of ducks, hens,
turkeys and peacocks walked about in the company of
four or five cats. It was the home of an original, but
an original of great taste. The doctor no longer prac-
ticed in Auvers, but had an office in Paris where he
held consultations several days a week; the rest of the
time he painted and etched in his room, which looked
like the workshop of an alchemist of the Middle Ages.

Soon after, on June 10, we received an invitation
from him to spend a whole day in Auvers and bring

Opposite: Dr. Gachet, 1890

Street in Auvers,
May 1890

the baby. Vincent came to meet us at the train, and he brought a bird's nest as a plaything for his little nephew and namesake. He insisted upon carrying the baby himself and had no rest until he had shown him all the animals in the yard. A too-loudly crowing cock made the baby red in the face with fear and made him cry; Vincent cried laughingly, 'The cock crows *cocorico*,' and was very proud that he had introduced his little namesake to the animal world. We lunched in the open air, and afterward took a long walk; the day was so peacefully quiet, so happy, that nobody would have suspected how tragically our happiness was to be destroyed a few weeks later. Early in July, Vincent visited us once more in Paris. We were exhausted by a serious illness of the baby; Theo was again considering the old plan of leaving Goupil and setting up in business for himself; Vincent was not satisfied with the place where the pictures were kept, and our removal to a larger apartment was talked of – so those were days of much worry and anxiety. Many friends came to visit Vincent – among others Aurier, who had recently written his famous article about Vincent* and now came again to look at the pictures with the painter himself. Toulouse Lautrec stayed for lunch

*Albert Aurier, 'Les isolés: Vincent van Gogh', *Mercure de France*, January 1890.

and made many jokes with Vincent about an under-taker's man they had met on the stairs. Guillaumin was also expected, but it became too much for Vincent, so he did not wait for this visit but hurried back to Auvers – overtired and excited, as his last let-ters and pictures show, in which the threatening catas-trophe seems approaching like the ominous black birds that dart through the storm over the wheat fields.

'I hope he is not getting melancholy or that a new attack is threatening again, everything has gone so well lately,' Theo wrote to me on July 20, after he had taken the baby and me to Holland and had returned to Paris for a short time, until he also could take a vacation. On July 25 he wrote to me, 'I have a letter from Vincent which seems quite incomprehensible; when will there come a happy time for him? He is so thoroughly good.' That happy time was never to come for Vincent; fear of an impending attack or the attack itself drove him to death.

On the evening of July 27 he shot himself with a revolver. Dr. Gachet wrote that same evening to Theo: 'With the greatest regret I must disturb your repose. Yet I think it my duty to write to you immedi-ately. At nine o'clock in the evening of today, Sunday, I was sent for by your brother Vincent, who wanted to

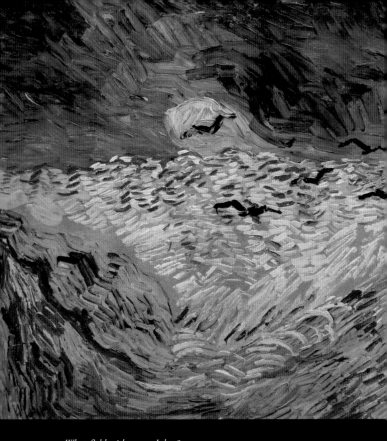

Wheatfield with crows, July 1890

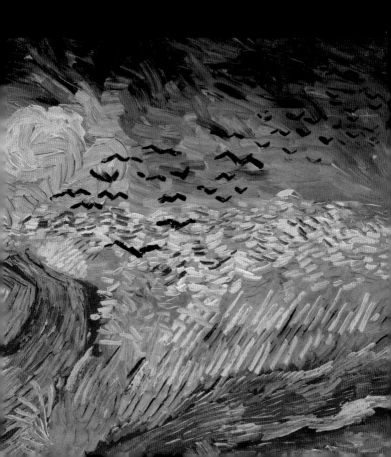

see me at once. I went there and found him very ill. He has wounded himself ... as I did not know your address and he refused to give it to me, this note will reach you through Goupil.' Consequently, the letter did not reach Theo until the next morning; he immediately started for Auvers. From there he wrote to me the same day, July 28, 'This morning a Dutch painter* who also lives in Auvers brought me a letter from Dr. Gachet that contained bad news about Vincent and asked me to come. Leaving everything, I went and found him somewhat better than I expected. I will not write the particulars, they are too sad, but you must know, dearest, that his life may be in danger ...

'He was glad that I came and we are together all the time ... poor fellow, very little happiness fell to his share, and no illusions are left him. The burden grows too heavy at times, he feels so alone. He often asks after you and the baby, and said that you could not imagine there was so much sorrow in life. Oh! if we could only give him some new courage to live. Don't get too anxious; his condition has been just as hopeless before, but his strong constitution deceived the doctors.' This hope proved idle. Early in the morning of July 29 Vincent passed away.

*Anton Hirschig

Theo wrote to me, 'One of his last words was, 'I wish I could pass away like this,' and his wish was fulfilled. A few moments and all was over. He had found the rest he could not find on earth ... The next morning there came from Paris and elsewhere eight friends who decked the room where the coffin stood with his pictures, which came out wonderfully. There were many flowers and wreaths. Dr. Gachet was the first to bring a large bunch of sunflowers, because Vincent was so fond of them ...

'He rests in a sunny spot amid the wheat fields ...'

From a letter of Theo's to his mother: 'One cannot write how grieved one is nor find any comfort. It is a grief that will last and which I certainly shall never forget as long as I live; the only thing one might say is that he himself has the rest he was longing for ... Life was such a burden to him; but now, as often happens, everybody is full of praise for his talents ... Oh Mother! he was so my own, own brother.'

Theo's frail health was broken. Six months later, on January 25, 1891, he followed his brother.

They rest side by side in the little cemetery amid the wheat fields of Auvers.

J. VAN GOGH-BONGER, December, 1913

Overleaf: Green wheatfields, Auvers, 1890

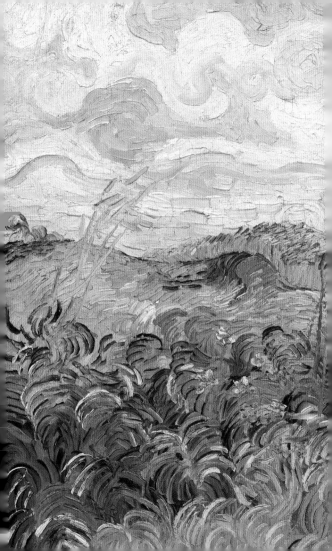

LIST OF ILLUSTRATIONS

All works oil on canvas unless stated otherwise

pp. 70-71: Women carrying coal, watercolour on paper,
Kröller-Müller Museum, Otterlo

pp: 74-75: Road in Etten, 1881, chalk, pencil, pastel, watercolour over pen and
brown ink, 39 x 58 cm, Metropolitan Museum of Art, New York

p. 78: Orphan Man, Standing, 1882, lithograph, sheet 54 x 38 cm,
National Gallery of Art, Washington, DC

p. 81: 'Sorrow', 1882, pencil and ink on paper, 44 x 27 cm, Art Gallery, Walsall

pp. 82-83: Nursery on the Schenkweg, The Hague, 1882, chalk, graphite, pen,
brush, and ink, heightened with white on laid paper, 29 x 58 cm,
Metropolitan Museum of Art, New York

pp. 86-87: Flower Beds in Holland, c. 1883, oil on canvas on wood, 49 x 66 cm,
National Gallery of Art, Washington, DC

p. 89: Two women on the heath, 1883, Kröller-Müller Museum, Otterlo

p. 92: The Parsonage Garden at Nuenen in Winter, 1884,
pen and brown ink, lead white on paper, 51 x 38 cm,
Museum of Fine Arts, Budapest

p. 97: A weaver's cottage, July 1884, oil on canvas mounted on wood,
47 x 61 cm, Museum Boijmans Van Beuningen, Rotterdam

p. 102: Still life with Bible, extinguished candle and novel, 66 x 78 cm,
Van Gogh Museum, Amsterdam

pp. 104-5: The Potato Eaters, 1885, 82 × 114 cm,
Van Gogh Museum, Amsterdam

p. 108: Head of a skeleton with burning cigarette, c. 1885-86, 32 × 24 cm,
Van Gogh Museum, Amsterdam

p. 111: View from Theo's apartment in the Rue Lepic, 46 x 38 cm,
Van Gogh Museum, Amsterdam

pp. 112-13: View of Paris, June-July 1886, 54 x 73 cm,
Van Gogh Museum, Amsterdam

p. 114: Self-Portrait with Grey Felt Hat, Winter 1886/87, oil on pasteboard,
41 x 32 cm, Rijksmuseum, Amsterdam

pp. 116-17: Montmartre: Windmills and Allotments, March-April 1887
45 x 81 cm, Van Gogh Museum, Amsterdam

p. 119: Vase with gladioli and Chinese asters, 1886, 46 x 38 cm,
Van Gogh Museum, Amsterdam

p. 123: Entrance of Voyer d'Argenson Park at Asnières, 1887, 55 x 67 cm,
Israel Museum, Jerusalem

p. 125: Père Tanguy, 1888, 68 x 51 cm, private collection

p. 126: Still life (Quinces, lemons, pears and grapes), 48 x 65 cm,
Van Gogh Museum, Amsterdam

p. 129: Flowering peach tree, April/May 1888, 80 x 59 cm,
Van Gogh Museum, Amsterdam

pp. 130-31: Starry Night over the Rhone, 1888, 72 x 92 cm, Musée d'Orsay, Paris

© 2015, 2021 Pallas Athene
Second printing

First published in the United States of America in 2018 by the J. Paul Getty Museum, Los Angeles
Getty Publications
1200 Getty Center Drive, Suite 500
Los Angeles, California 90049-1682
www.getty.edu/publications

Distributed in the United States and Canada by the University of Chicago Press

Printed in China

ISBN 978-1-60606-560-0
Library of Congress Control Number: 2017946353

Published in the United Kingdom by Pallas Athene (Publishers) Ltd.
2 Birch Close, London N19 5XD

Alexander Fyjis-Walker, *Series Editor*

Front cover: Vincent van Gogh (Dutch, 1853–1890), *Self-Portrait*, August 1889 (detail).
National Gallery of Art, Washington, DC